Infinite wisdom is bound up in each particle of the universe.

The fine, powdery, white sands of the Florida panhandle came from Appalachian Mountain quartz pebbles, delivered to the sea by continental rivers such as the Apalachicola River. Waves during storms, and even calm seas such as these, have continually ground the grains together making some of the finest powdery sand beaches in the world. *Shell Island, St. Andrews State Park, Panama City Beach.*

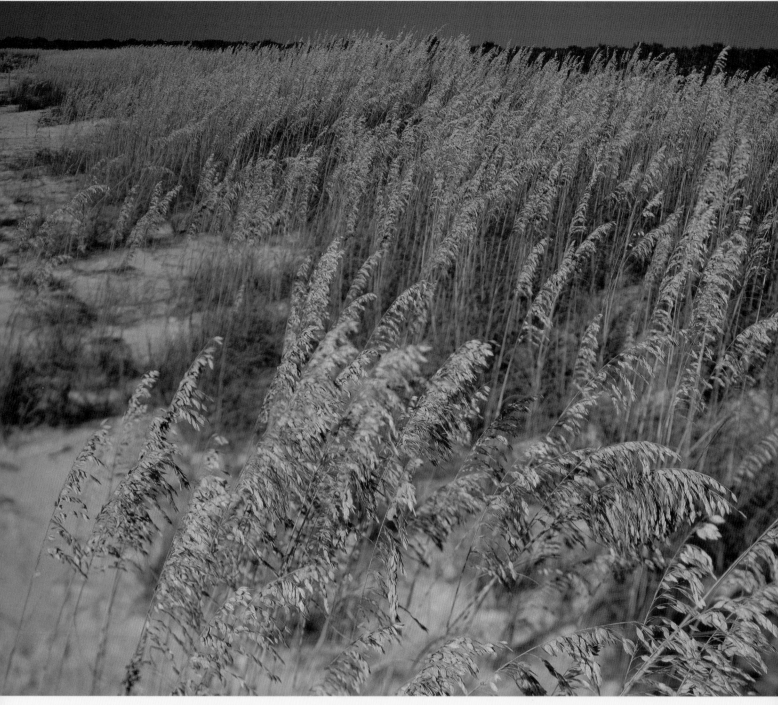

Embers of golden light embrace your being, a unified gift to all who listen.

Sea oats, here in one of the largest stands in the state, protect coastal dunes with their dense root system. Other plants are smothered as sands bury the live stems, but new roots sprout from the nodes of sea oats and this coarse grass keeps growing upwards. *Caladesi Island State Park, Dunedin.*

Facing Page:
A newborn loggerhead sea turtle, following an instinctive homing, scurries past a baby horse conch (Florida's official seashell) on its way to the Atlantic Ocean. Sea turtles hatch at night or late in the afternoon to escape the many predators awaiting them, not the least of which are herons, egrets, and hawks. *Bahia Honda State Park, Bahia Honda Key*

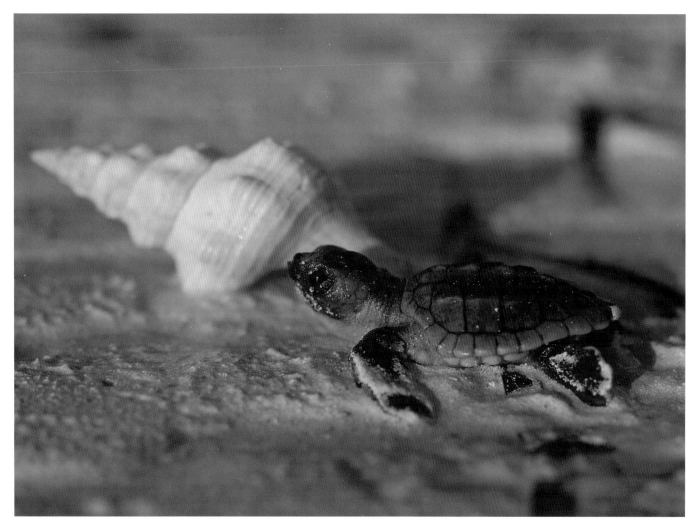

Primordial innocence, an ancient connection with the Earth.

# Florida's
# Magnificent
# Coast

## James Valentine
## and D. Bruce Means

Pineapple Press, Inc.
Sarasota, Florida

A freshwater stream meets the Gulf shore.
*Camp Creek, Bay County.*

Bay of tranquility, endless possibility.

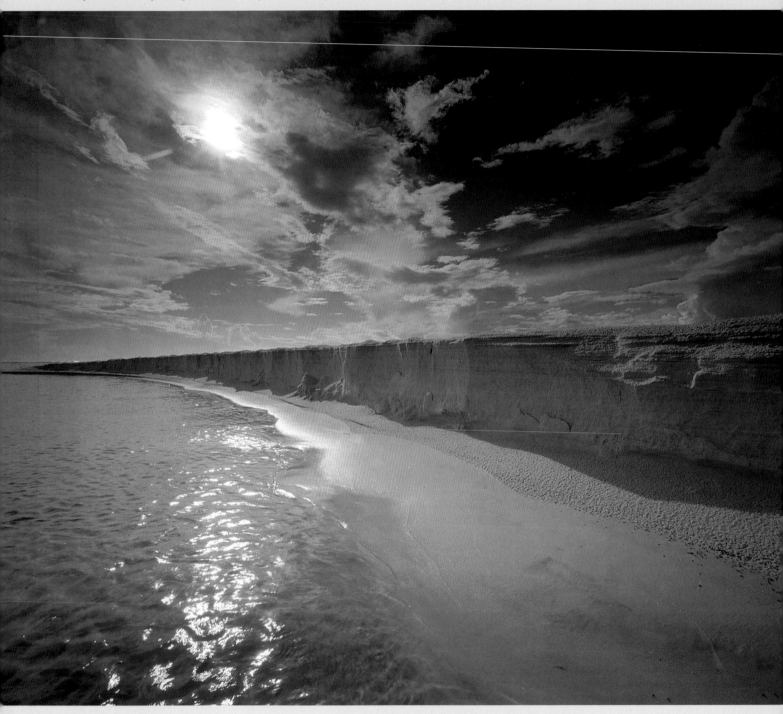

Inquiries should be addressed to:
Pineapple Press, Inc.
P.O. Box 3889
Sarasota, Florida 34230

www.pineapplepress.com

Library of Congress Cataloging-in-Publication Data

Valentine, James.
    Florida's magnificent coast / James Valentine and D. Bruce Means.
        pages cm. — (Magnificent Florida)
ISBN 978-1-56164-719-4 (pbk. : alk. paper)
1. Florida—Description and travel. 2. Coasts—Florida. I. Means, D. Bruce. II. Title.
    F316.2.V35 2014
    917.59—dc23
                                                2014022977
First Edition
10 9 8 7 6 5 4 3 2 1

Design: Doris Halle                    Printed in Malaysia

# Preface

Jim Valentine

Florida is known for its world-class beaches and this is what comes to mind to most people visiting the state for the first time. Florida's west coast spans over 650 miles between Perdido Key State Park and the Ten Thousand Islands south of Marco Island. These coastal areas include not only pristine beaches, but also major river deltas, incredible bays, Florida's Nature Coast along the Big Bend Coast, hardwood hammocks, and hundreds of barrier islands teaming with wildlife. Florida's east coast spans over 400 miles between Fernandina Beach and Miami, starting with the wild barrier islands above Jacksonville. You will witness the mighty St. Johns River and hundreds of miles of the inland waterway that is adjacent to beautiful salt- and freshwater marshes, hardwood hammocks, and bay systems. Both of the Florida coastlines have their own unique wild charm where you can explore many special wilderness areas. Over four decades, I have explored Florida ecosystems and learned how very important it is to seek the wildest places in the heart of the coastal wilderness areas, no matter how big or small.

Aerial photography plays a major role in depicting Florida's ecosystems because the state is basically flat and has little topographic relief. Beaches and barrier islands are the connecting points between the land and sea. Every beach has its own individual magical ecosystem as you feel the thousands of minute sand textures mixed with various sized shells under your feet and feast your eyes on the ever-changing reflections of light dancing over the beach and dune landscapes. Very memorable experiences happen when you witness one of Florida's largest dunes cut in half by Hurricane Opal on St. Joseph Peninsula State Park or perceive the fabric of life as morning glories open their beauty under golden sea oats on Little Talbot Island State Park.

Marshes and mangroves along the Gulf Coast offer a nursery at the edge of the sea providing a safe haven for untold trillions of plants, organisms, and wildlife to be born into this world. The entire tideland complex of barrier islands, marshes, creeks, and river deltas is a single operational unit linked together by the action of the tide and the direct rays of the sun. The marsh network acts as a great sponge, absorbing tremendous amounts of moisture as a protective barrier for land against storm waves and flood tides. The aerial photo along the Big Bend Coast showcases the wind-blown seas trying to cross the marsh. The Ten Thousand Islands are vital to the maintenance of the ecosystem and productivity of certain species. Its "annual" tides draw down fish ponds due to the rise and fall of water.

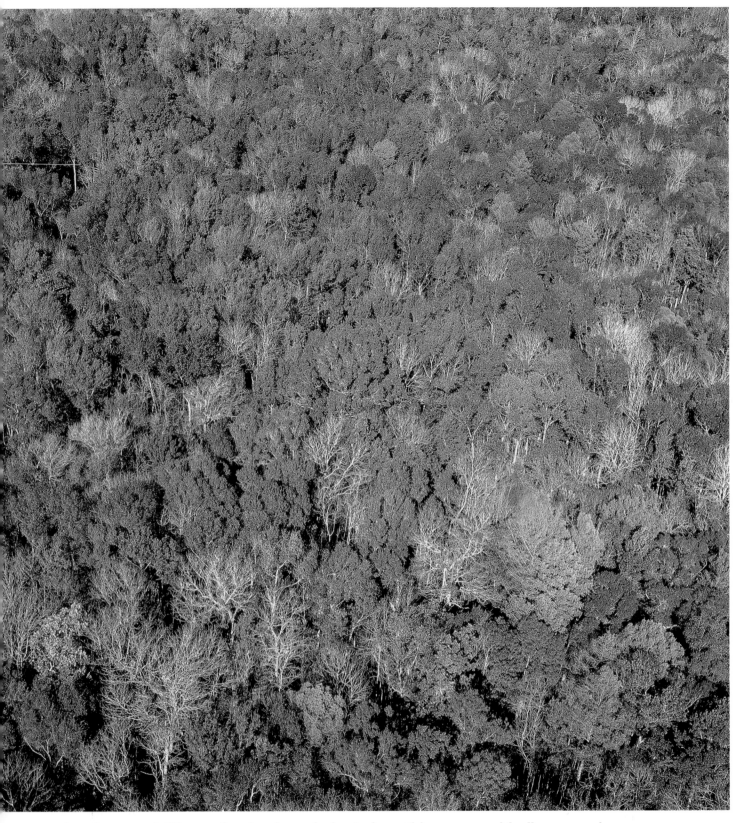

**Awaken . . . trillions of animals and plants breathing as one biodiverse voice.**

Autumn canopy of a hydric hammock in Florida's Big Bend. In a celebration of canopy biodiversity, the leafless treetops are blackgum or black tupelo *(Nyssa sylvatica),* the red leaves are sweetgum *(Liquid-ambar styraciflua),* and the green leaves are water oak *(Quercus nigra)* and sweet bay magnolia *(Magnolia virginiana). Florida's Nature Coast, Taylor County.*

The consciousness of Nature germinates all things.

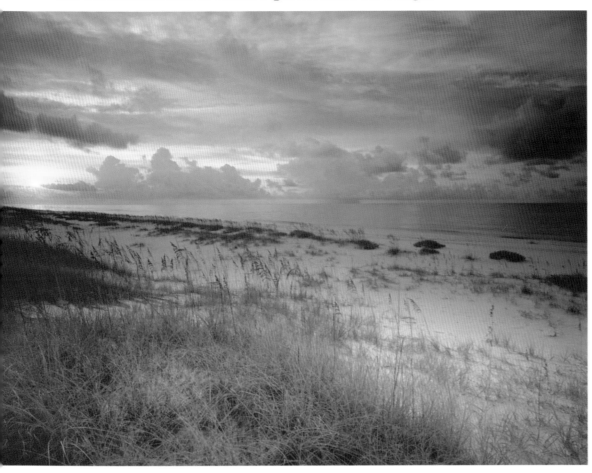

High tide has all but inundated the beach. The low dune on the right with sea oats and rosemary is a recently deposited beach ridge being built up with sand blowing inland. Next is a narrow inter-dune flat, and then an older, higher foredune. *Perdido Key State Park, Escambia County.*

Trillions of sacred biological connecting points
Join life together in the ocean nursery
Making life possible on Mother Earth.

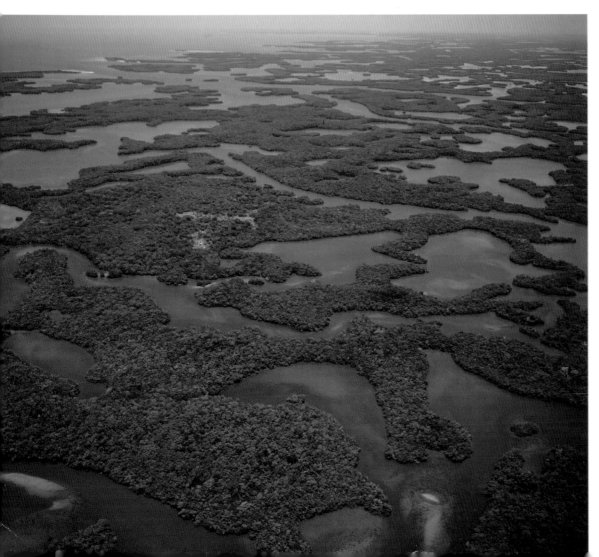

Lying between Everglades National Park on the east and Rookery Bay Aquatic Preserve on the west, the Cape Romano-Ten Thousand Islands Aquatic Preserve is primarily open water and mangroves. Its estuarine waters are fed by numerous small rivers and canals flowing slowly off the adjacent land in southwest Collier County. The estuary is an important nursery for fish, crabs, shrimp, and other sea life in the Florida Bay and the Gulf of Mexico. *Cape Romano-Ten Thousand Islands Aquatic Preserve.*

# Introduction

D. Bruce Means

Probably no other natural feature is more associated with Florida than its 1,350 miles of coastline. Florida ranks second in the nation after Alaska for miles of it. If the precise contour at average sea level is measured following every bend and twist of the coastline and circumscribing every island, the actual shoreline of sandy beaches, salt marshes, and mangroves amounts to 8,436 miles. Tourists and residents alike are drawn to Florida's beaches and salt water. Ninety percent of Floridians live within ten miles of the seacoast.

The seashore is the threshold of a great variety of different habitats formed offshore by salt water. Under the surface of the ocean lie many habitats such as coral reefs, worm reefs, mud bottoms, seagrass communities, and the pelagic water column. These are distributed off Florida's extensive coastline according to water temperature, sediment supply, ocean currents, freshwater inputs from the land, and wind and wave action. Florida's geographical context—a peninsula jutting nearly 500 miles southward into subtropical latitudes—plays a strong role governing the occurrence of plants, animals, and habitats both underwater offshore and on land near the coast.

A very important phenomenon governing the physical properties of Florida's coastlines is wave action. The stronger waves are as they break upon the land, the more energy they contain. Wave energy is dependent upon the depth of the water offshore because physics dictates that waves drag on the sea bottom. Deeper water produces less drag than shallow water. Wherever the offshore depth of the ocean is deepest, there is less drag and stronger waves. Conversely, where offshore water depth is shallow, wave energy is attenuated.

**Rippling, moving, touching your being with Nature's ancient biorhythms.**

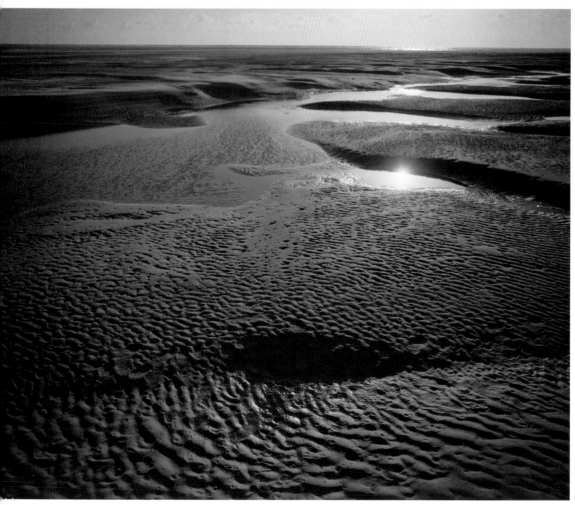

One of the few remaining undeveloped barrier islands in northeast Florida, Little Talbot Island State Park lies just north of the mouth of the St. Johns River in Nassau County. Tidal flats shown here appear devoid of life, but microscopic life abounds between the sand grains with an infauna of crustaceans and other invertebrates that have burrowed into the substrate awaiting the return of salt water. Ripple marks were made by water as the tide retreated, but at this moment sand grains are drying and available for offshore winds to blow them inland where they may add to the sand of the beach or be dropped to form growing dunes just beyond. *Little Talbot Island State Park.*

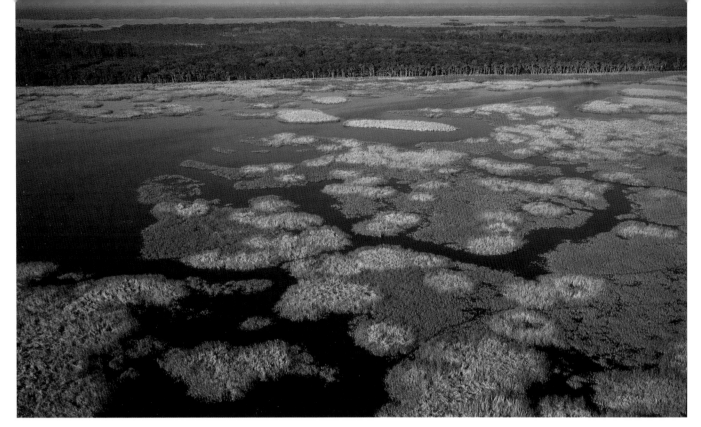

Inventive, creative, effective—an endless fecund cycle of life.

The Guana River parallels the Atlantic coast for 18 miles from Ponte Vedra Beach to St. Augustine at Matanzas Bay. It lies in a wide coastal swale just west of the dunes and east of the Intracoastal Waterway and Tolomato River. It is predominantly a shallow freshwater marsh above a dam and has saltwater and estuarine marshes below it. It is part of the Guana Tolomato Matanzas National Estuarine Research Reserve's 60,000 acres of beaches, sand dunes, salt marshes, mangroves, tidal wetlands, tidal creeks, oyster beds, estuarine lagoons, maritime hardwood hammock, freshwater depression marshes, pond pine flatwoods, and shell mound forests. *Guana RIver between Ponte Vedra and St. Augustine.*

The Florida peninsula lies on the Florida Platform, which is a broad, plateau jutting south from the edge of the North American continent. Present-day Florida lies above sea level, but only about half of the Florida Platform is exposed to the air. Offshore, especially to the west and south, the Florida Platform lies less than 300 feet under sea level. During times when the sea level was much lower, such as in the last Pleistocene glacial age that ended only about 10,000 years ago, so much of the Florida Platform was exposed that the state as we know it was doubled in area. Today, the Platform drops off most deeply along the Atlantic coast and also along the Florida panhandle to the west from about Panama City. These are Florida's high-energy coastlines. South of the peninsula and along the entire peninsular west coast—because sea level is less than 300 feet deep for about 150 miles westward—Florida has low-energy coastlines. Florida's two high- and two low-energy coastlines are quite different from each other, giving mainland Florida four very different coastal regions.

High-energy coastlines are sculpted by wave action. When strong winds blow waves against the coast, offshore sediments are thrown up as beach ridges paralleling the coast. Because sea levels have been relatively stable in the past 6,000 years, barrier islands comprised of many parallel beach ridges lie all along the Atlantic coastline of Florida. If subsequent winds do not erode the new beach ridge—a common occurrence—then the barrier island grows seaward with each new beach ridge. During low tides, sand grains dry out, blow inland, and may pile up as dunes, causing a beach ridge to grow upward. Barrier islands widen, therefore, as they accumulate parallel sets of dune-decorated beach ridges with interdune flats between them.

Merritt Island is Florida's largest east coast barrier island. It is located about halfway down the peninsula with a portion jutting eastward as Cape Canaveral. Cape Canaveral was chosen as the most favorable site for the Spaceport Florida Launch Complex of the Cape Canaveral Air Force Station because the earth's rotation assists in the eastward launching of rockets and it is highly desirable to have the downrange area unpopulated, in case of accidents. Barrier islands all along Florida's east coast lie east of elongated brackish lagoons. Indian River is a 121-mile-long part of the Indian River Lagoon system that forms the Atlantic Intracoastal Waterway. The barrier islands protect ships and boat traffic from storms.

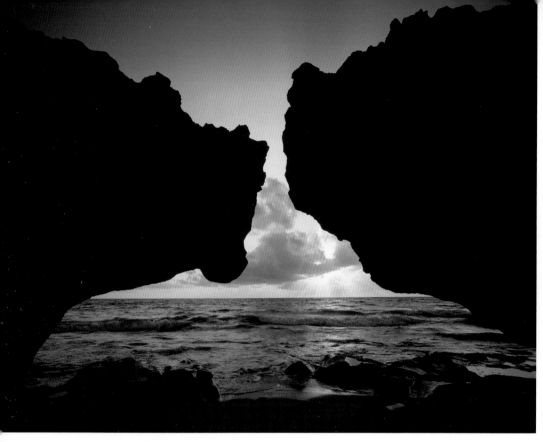

Blowing Rocks Preserve was named for its rocky Anastasia limestone shoreline, the largest on the U.S. Atlantic coast. During extreme high tides and after winter storms, seas break against the rocks and force plumes of salt water up to 50 feet skyward. The carefully restored habitats found here are disappearing fast from many Florida islands, and a number of endangered plants and animals call this special place home— including rare loggerhead, green, and leatherback sea turtles. *The Nature Conservancy, Tequesta.*

Standing firm, unyielding only to slowly return to the sea.

Atlantic Coast beaches are largely formed of fragments of sea creatures, such as mollusks and echinoderms. The reason for this is mainly due to the lack of inorganic sand, because few rivers along the Atlantic coast supply huge loads of siliceous sand to the sea. The big St. Johns River flowing into the Atlantic Ocean at Jacksonville runs south to north through relatively low-lying terrain and brings little sediment with it. Tiny clams called coquina are abundant along the eastern seashore. Over millennia, their shells have built up deep deposits of coquina rock, a special kind of limestone for which parts of Florida's Atlantic Coast is famous.

The Florida Keys have a complicated history. They are the exposed portions of an ancient coral reef, but the northern keys are formed of different limestones than the southern keys. Beginning about 130,000 years ago, all of southern Florida was covered by a shallow sea. Several parallel lines of reef formed along the edge of the submerged Florida Platform, stretching south and then west from the present Miami area to what is now the Dry Tortugas. This reef formed the Key Largo limestone that is exposed on the surface from Soldier Key to the southeast portion of Big Pine Key.

Starting about 100,000 years ago, the Wisconsin glaciation began lowering sea levels, exposing the coral reef and surrounding marine sediments. By 15,000 years ago the sea level had dropped to 300 to 350 feet below its present level. The exposed reefs and sediments were heavily eroded by dissolution from rainfall. Some of the dissolved limestone was redeposited as a denser cap rock, which can be seen as outcrops overlying the Key Largo and Miami limestones throughout the Keys. The limestone that eroded from the reef formed oolites, or oval grains, in the shallow sea behind the reef. Together with the skeletal remains of marine animals called bryozoans, they formed the Miami limestone that is the current surface bedrock of the lower Florida peninsula and the lower keys from Big Pine Key to Key West.

Just offshore to the east of the Florida Keys along the edge of the Florida Straits, the Florida Reef extends 160 miles from just east of Soldier Key to just south of the Marquesas Keys. It is the third-largest barrier reef system in the world and one of Florida's most precious marine ecosystems. To the west, the Florida Keys protect the shallow waters of Florida Bay, its  mangrove islands, and the extensive south Florida coastline of mangroves. Most of Florida Bay and associated mangrove communities are included in Everglades National Park. Mangrove communities reach halfway up the peninsula on Florida's west coast but only a short distance up the east coast.

Because so much of the submerged, shallow Florida Platform lies adjacent to peninsular Florida's western coastline, wave energy is much reduced in comparison with the east coast. North of the mangroves from about Tampa to the mouth of the Ochlockonee River, the coastline has no sandy shores.  It is dominated by extensive salt marshes that

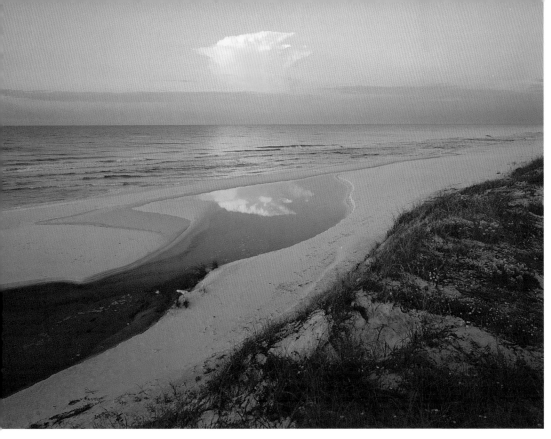

Emerald waters of a rising tide push sand against the slow current of a small creek as it delivers its fresh water to the Gulf of Mexico. Here the beach or littoral area—land between high and low tides—runs right up to the vegetated foredunes, but only extremely high tides or seawater pushed inland by storms reach their base. Upland plants cannot grow in the salty sands, nor survive immersion in the salt water. However, the sand is full of life, beginning with microscopic one-celled algae, and bigger life, such as crustaceans and clams. *Topsail Hill Preserve State Park, Destin.*

Deep within we are always connected to the divine golden light.

transition seaward into extensive seagrass beds. No sediment-laden rivers deliver much sand to the coast, for one thing, even the Suwannee River. The salt marshes and seagrass beds provide a huge nursery for marine fishes and invertebrates of the Gulf of Mexico. They are responsible for much of the seafood—crabs, shrimp, scallops, grouper, snapper, other fishes—that Floridians enjoy catching and eating. The seagrass beds are among the most extensive in the world and are vital to supporting manatees and some of Florida's sea turtles.

Florida's coastline west of the Ochlockonee River becomes high energy again as the Florida Platform drops off more steeply and huge loads of sandy sediments are delivered to the seashore by large continental rivers such as the Apalachicola, Choctawhatchee, and Escambia. Western panhandle Florida is famous for its blazing white, sugar-sand beaches, which attract visitors from inland states in droves. Offshore once again lies an extensive line of barrier islands. Understanding the dynamics of how barrier islands form gives us insight to all of Florida, which, at one time or another, has all been under the sea.

The ocean is directly responsible for the creation of new land underfoot. Looking inland from the beach, we see dryland habitats created by the action of wind and waves. Sand and other sediments, such as seashells and the hard body parts of sand dollars and sea urchins, are thrown up daily by waves onto beaches—the first land emerging from the water. As beach sand dries out between tides, it is blown inland by offshore winds, where it accumulates in dune fields immediately behind the beach. One can see dunes up to forty feet tall on some high-energy coastlines of west Florida.

Waves create new land next to the seashore, as does wind. Periodically during certain climatic conditions, waves build up a new beach ridge above high tide parallel with the shore, creating new land on top of which new dunes can grow. In this manner the coastline grows seaward with the addition of each new beach ridge. This very process established Florida's many barrier islands.

Inland from the beach, the first dunes that are encountered—the actively growing dunes—are called foredunes. Only a few plants can tolerate the hostile foredune environment because of the shifting sand, salt spray, and intense sunlight. But those that become rooted on the foredunes are very special plants because they assist the process of dune formation. As long as nothing obstructs the wind, sand blows freely across flat places and does not accumulate. However, stems of sea oats, for example, offer slight resistance to the wind, upsetting its carrying power sufficiently so that sand accumulates where sea oats grow. As sand rises, it buries the sea oats, but this species is noted for rapid

11

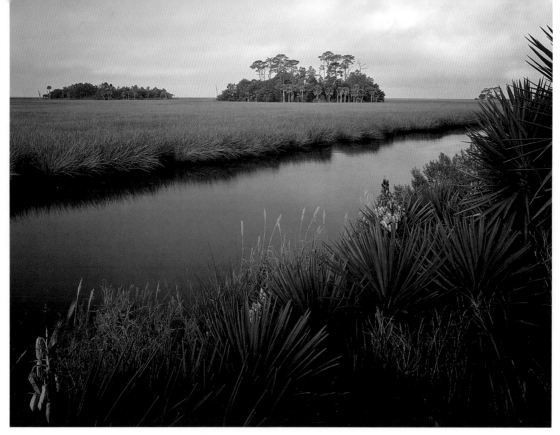

Oh, fecund marsh, show us your largesse—such organic bounty.

Marshes and hammocks abound along the Big Bend coast. Looking westward from the southwest corner of Hickory Mound—a freshwater impoundment created for migratory waterfowl—salt marshes extend to the open Gulf of Mexico. Rising from the salt marshes are many hardwood hammock islands, some of which are Indian middens built up as shell mounds. The salt marshes and tidal creeks are some of Florida's most productive nurseries for crabs, shrimp, and fish. *Hickory Mound, managed by the Florida Fish and Wildlife Conservation Commission, southeast of Econfina State Park.*

upward growth that keeps pace with the deepening sand. New roots grow out from the old nodes of the stem. Thus, any plants that can survive on the top of the foredunes actually assist in the growth of the dunes. Moreover, during high winds that have the power to blow large amounts of dune sand away, dunes are protected from erosion by the dense roots of these same plants. That is why it is inadvisable to interfere with the dune stabilization process by picking sea oats or walking on dunes and making paths in the vegetation, which gives the wind an opening to blow the dune away.

Inland from the foredunes lie the older back dunes, which were created in their time at the beachfront. These can be higher, lower, or consist of a series of independent mounds, depending on their history of deposition and erosion. Back dunes support coastal scrub communities of wiry oaks, rosemaries, and other coastal vegetation. The main feature of these vegetations often is their stunted and sculpted appearance, caused by salt spray blowing inland off the ocean, which kills the growing buds at the tips of branches, effectively pruning the plants. Interdune flats are vegetated with a variety of grasses and herbs and often have freshwater marshes standing in them.

Sandy coastline in Florida is continuous on the Atlantic coast north from Miami. It is largely absent from the Keys and Florida Bay, but present on the west coast from Cape Romano to the Anclote Keys just north of Tampa. From the Anclote Keys north to the mouth of the Ochlockonee River, the coastline is free of exposed sand, supporting mostly shallow seagrass beds and salt marsh vegetation. This is a low-energy coastline, meaning that wind and wave action don't beat upon the shoreline as it does along the sandy coastlines. Its low energy derives from the shallow Florida Platform that lies under the sea parallel with the west coast and about as wide as the peninsula. High-energy waves cannot easily develop in shallow waters. West of the Ochlockonee River where the sea floor slopes downward more steeply, the panhandle shores again are a high-energy coastline with pure white quartz sand beaches and barrier islands.

Saltmarshes and mangroves are developed along the coastline of Florida in the intertidal zone of low-energy coastlines and estuaries. The vegetation of both of these communities is not rich with plant species, but both are vitally important as nursery areas for many commercial and recreational animals, such as crabs, shrimps, and fishes. The food webs of the marine environment are extremely dependent on the high productivity in the coastal estuarine habitats.

Standing at the water's edge and looking out to sea, we often overlook the rich biodiversity that lies underwater. Breathing air and living on land as we do, the underwater world of the sea is alien to us, and is only visited briefly by the few people who snorkel or SCUBA dive. Offshore and underwater, Florida's biodiversity escalates dramatically. Not only does Florida possess the rich fish and invertebrate diversity common to both the Atlantic and Gulf of Mexico waters, but only Florida among the continental states also possesses the biodiversity of tropical coral reefs.

Few other areas feel the impact of human occupation greater than Florida's coastal habitats. Beachfront development and pollution of marine waters are widespread along Florida's coastlines. Development, however, may not be the worst impacts that Florida's coastlines will experience in the decades to come. Worldwide sea levels in the past century have risen about seven inches, so there has been little increase in barrier island growth. Along many of Florida's coastlines, one can see the effects of rising salt water, which has killed slash pines along the western panhandle coast and cabbage palms in coastal hydric hammocks of the Big Bend. What this means is that coastal environments are not disappearing, they are moving inland. Climate scientists have clearly documented that global climate is warming and sea levels are rising. Considering how much we stand to lose, not just in Florida but everywhere on our precious planet, we all need to take personal responsibility to do everything we can to arrest and then reverse the trends. Floridians must realize that our fabulous coastlines are under threat and resolve to appreciate them even more than we presently do. The photographs in this book may well become documentation of the precious natural treasures we once took for granted.   —D. Bruce Means

Endless, countless, measureless—your boundless island journey.

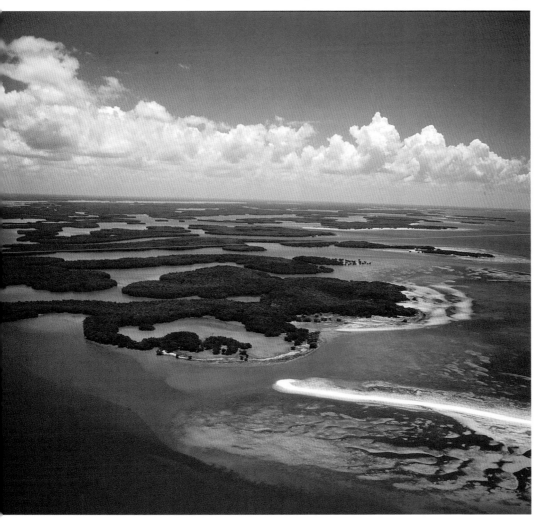

In the lower right, note the spit growing east from Round Key in the Ten Thousand Islands National Wildlife Refuge, part of the largest expanse of mangrove forest in North America. Mangrove forest dominates most tidal fringes and the numerous islands (or keys). Roughly 200 species of fish have been documented in the area and much of the seagrass beds and mangrove bottoms serve as vital nursery areas for marine fish. Over 189 species of birds use the refuge at some time during the year, including wading birds, shorebirds, diving water birds, and raptors. Common mammals found in the area include raccoon, river otter, and bottle-nosed dolphins. Notable threatened and endangered species include West Indian manatee, bald eagle, peregrine falcon, wood stork, and the Atlantic loggerhead, green, and Kemp's Ridley sea turtles. *The beginning of the Ten Thousand Islands National Wildlife Refuge. South of Marco, Collier County.*

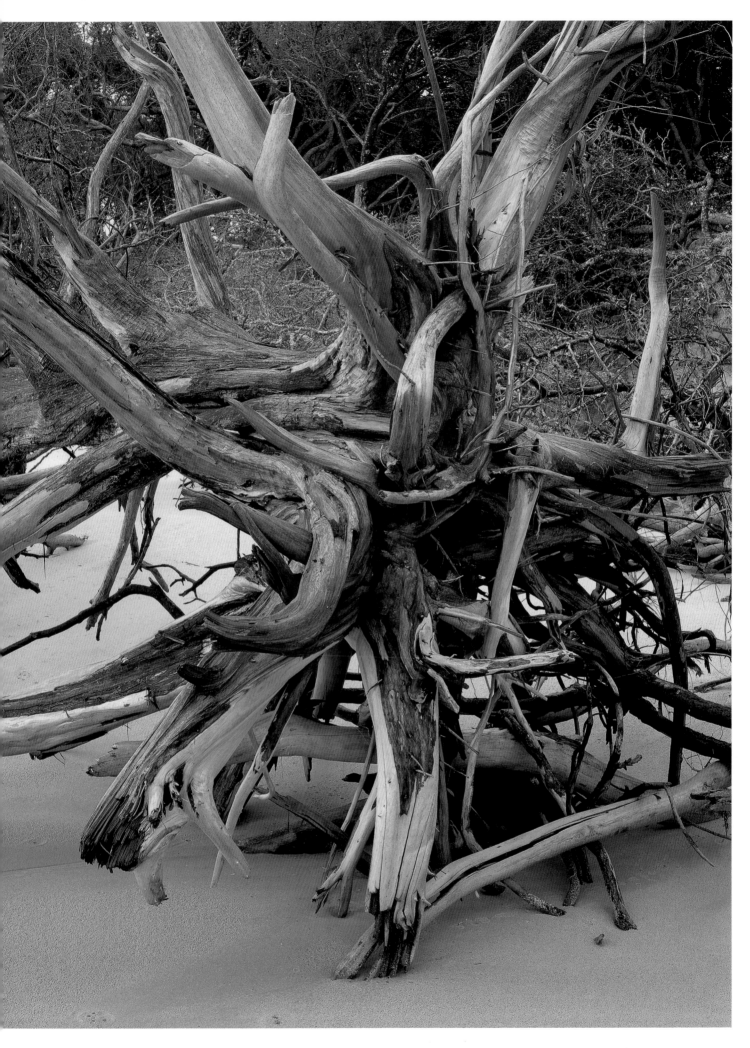

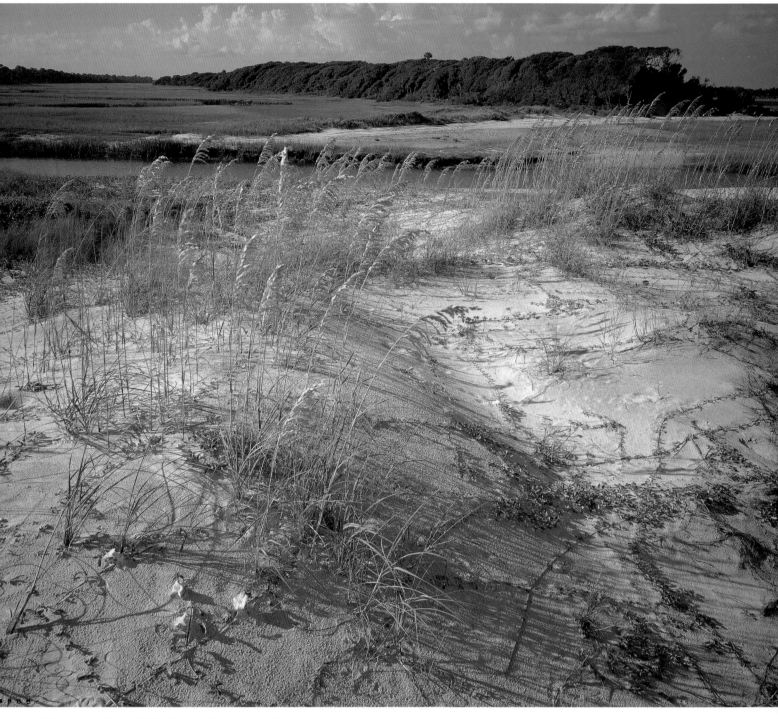

**The fabric of life beholds countless beauties.**

Sea oats *(Uniola paniculata)* and beach morning glory *(Ipomea imperati)* capture sand blowing inland off the beach and assist in the buildup of foredunes along Florida's seacoasts. The low dune in the foreground is actively accreting, but trees pruned by salt spray mark an ancient dune in the right background. *Little Talbot Island State Park, Fort George.*

**Nature's polished sculpture glorifies the beach.**

(Left): The upturned roots of a dead slash pine *(Pinus elliottii)* give evidence of rising sea levels. Around both Atlantic and Gulf shores of Florida, many dead slash pines stand on beaches, their roots exposed from wave action. Seas have inundated and receded from Florida many times. In fact, Florida was born from the sea, so the loss of a few feet—or thousands of feet—has been a recurring theme over time. *Big Talbot Island State Park, Jacksonville.*

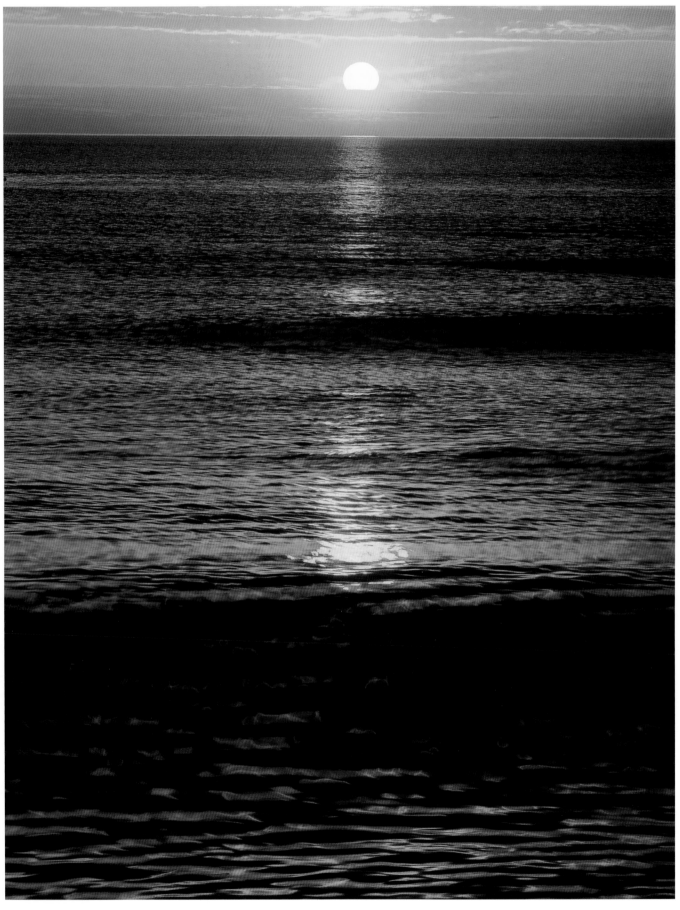

Light . . . healer of all things . . .

Sunlight drives the life forces on earth. It provides the energy that plants use during photosynthesis in making sugars, starches, cellulose, and proteins. Since most animals obtain their sustenance directly or indirectly from plants, animals, too, depend upon sunlight. Even though there are autotrophic ecosystems that do not rely on sunlight for energy, they do rely on it for warmth, so life on earth would perish without the sun. *Guana River State Park, south of Jacksonville Beach.*

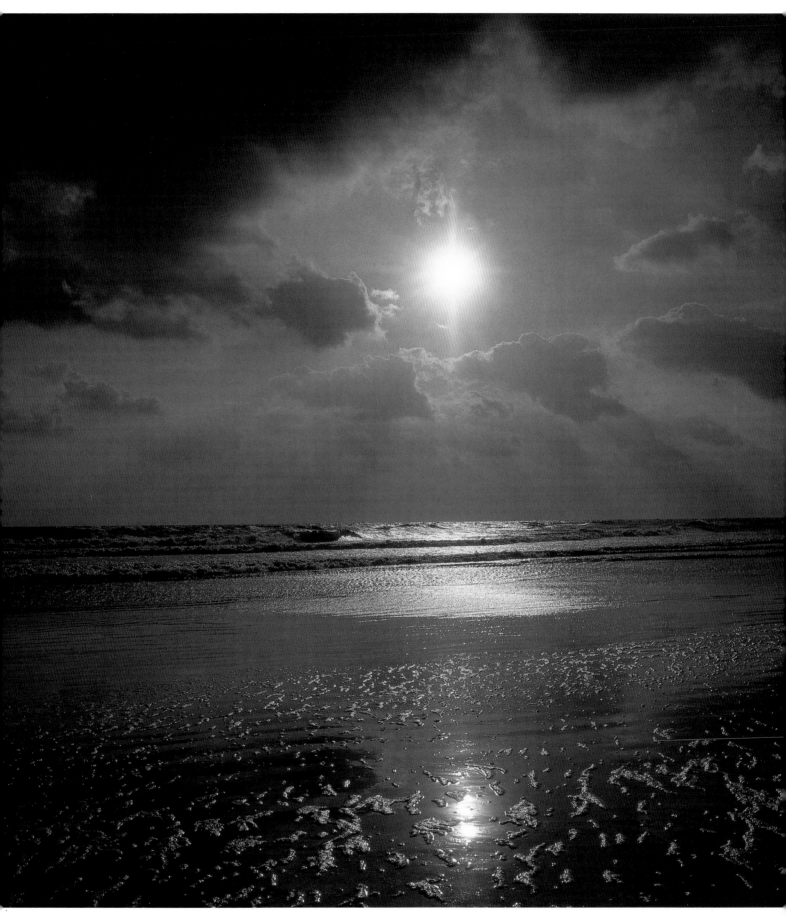

**A thousand meditations unfold in one sunrise.**

The intertidal zone along Florida's shores is a special place teeming with life. Bacteria and algae grow among the sand grains of the beach, and the sand contains clams, crustaceans, worms, crabs, and much other life. If you don't believe it, watch the exposed land during low tide and see the many different kinds of shorebirds probing for their food there. *Gamble Rogers Memorial State Recreation Area, Flagler Beach.*

Brackish marshes border a creek entering the lagoon between the mainland and a barrier island on Florida's east coast. Coastal marshes are among Florida's most productive ecosystems, cycling nutrients that ebb and flow through them from tidal action. *Pellicer Creek Aquatic Preserve at Faver-Dykes State Park, St. Johns County.*

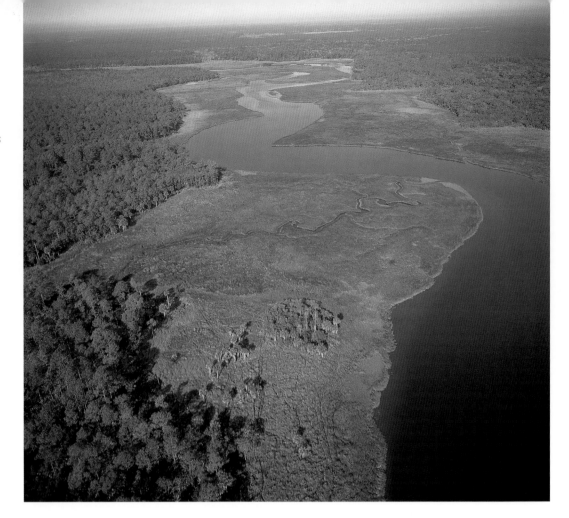

To fly like an eagle . . . brings everything into view.

The northeast end of Conch Island east of St. Augustine is growing seaward from sandy sediments dumped offshore by the Matanzas River at the St. Augustine Inlet below. The sand is carried south along shore and dumped on the beach by tides and storms. When the tide is down, the new sand blows inland where it forms new land, visible here as the foredune (the black line behind the beach) and scattered backdunes behind the foredune. *Anastasia State Park, St. Augustine.*

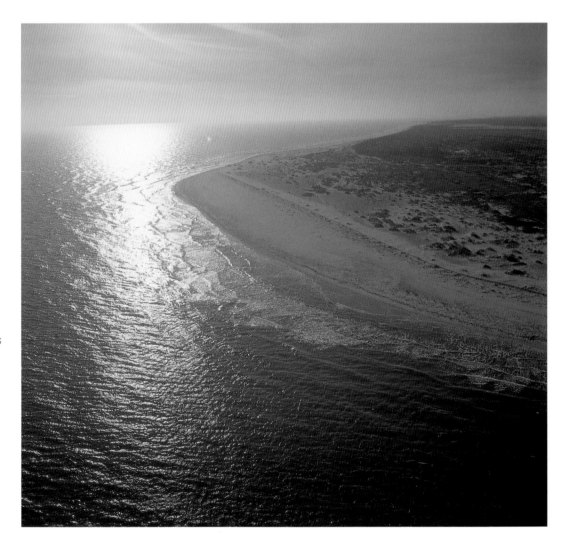

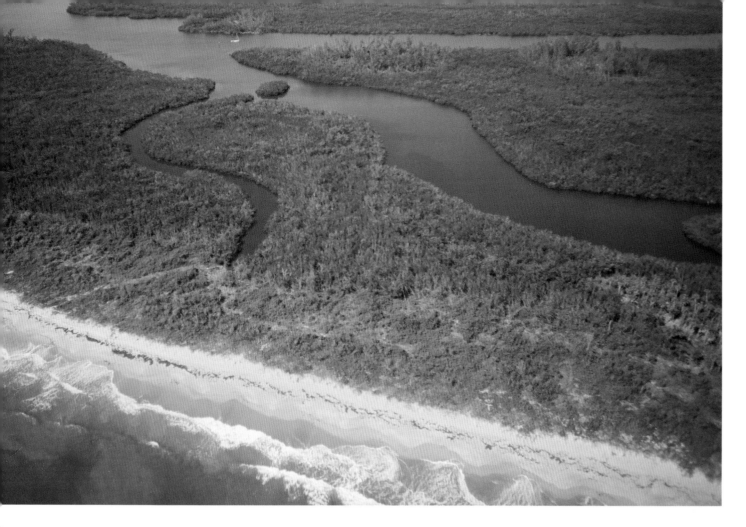

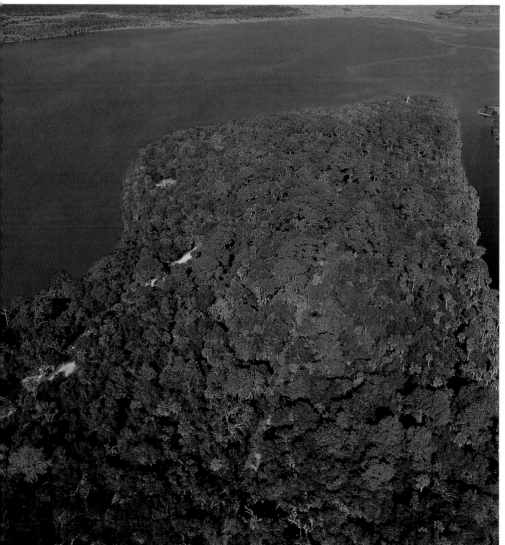

(Above) St. Lucie Inlet State Park (right side of image), and Hobe Sound National Wildlife Refuge (left side of image), protect some of the most productive sea turtle nesting beach habitat in the United States. Up to 2,000 nests yield annually 100,000 to 200,000 endangered loggerhead, leatherback, and green sea turtle hatchlings. The combined state and federal preserves are home to more than 40 plants and animals that are listed by the state or federal government as threatened, endangered, or of special concern. *Palm Beach County.*

Liveoaks *(Quercus virginiana)* and slash pines *(Pinus elliottii),* fringed by cabbage palms *(Sabal palmetto),* grow at the end of an ancient barrier island or spit, with the brackish water of Tomoka Basin wrapping around its northern end. *Tomoka State Park, Ormond Beach.*

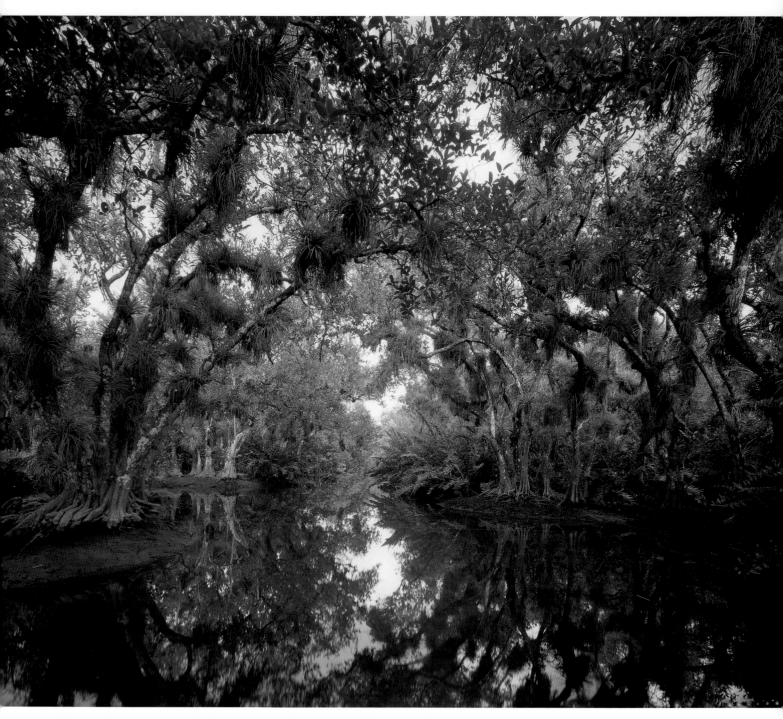

**Being in a swamp brings great joy . . . to discover I have many friends.**

Giant leather fern *(Acrostichum danaeifolium)* grows along the margins of a brackish swamp with pond apple *(Anonna glabra)*, a south Florida wetland tree. Large bromeliads (*Tillandsia* spp.) are epiphytes on the pond apples that once formed a forest fringe around the southern shore of Lake Okeechobee. Agriculture removed the pond apple forest, but it thrives in sloughs and wetlands throughout south Florida and is an invasive wetland pest in many parts of the world. *Pond Apple Slough, Ft. Lauderdale.*

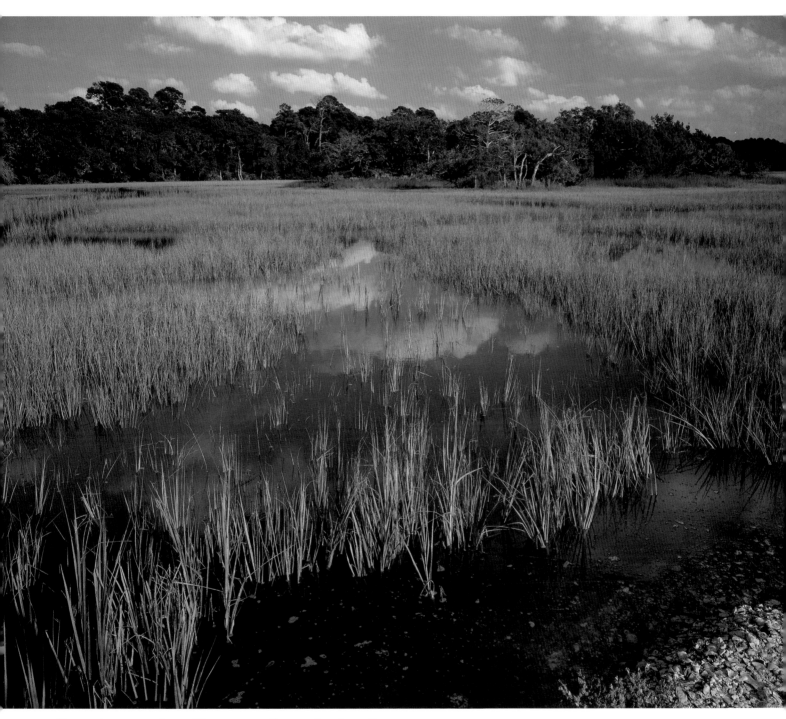

On quiet evenings Nature radiates in the silence.

Cordgrass (*Spartina* sp.) dominates a brackish marsh with slash pines and liveoaks on land in the background. This important marsh expanse is adjacent to the inland waterway that connects much of the east coast of Florida. *Guana River State Park, south of Jacksonville Beach.*

Coquina rock is a mixture of shell fragments and quartz grains held together by calcium carbonate that formed when higher sea levels covered the Florida coast. It lies under most of Florida's Atlantic shore. It is soft and easy to cut in the ground, but hardens when exposed to the air, and, in an earlier era, was extensively used to construct buildings. *Washington Oaks State Gardens, Palm Coast south of St. Augustine.*

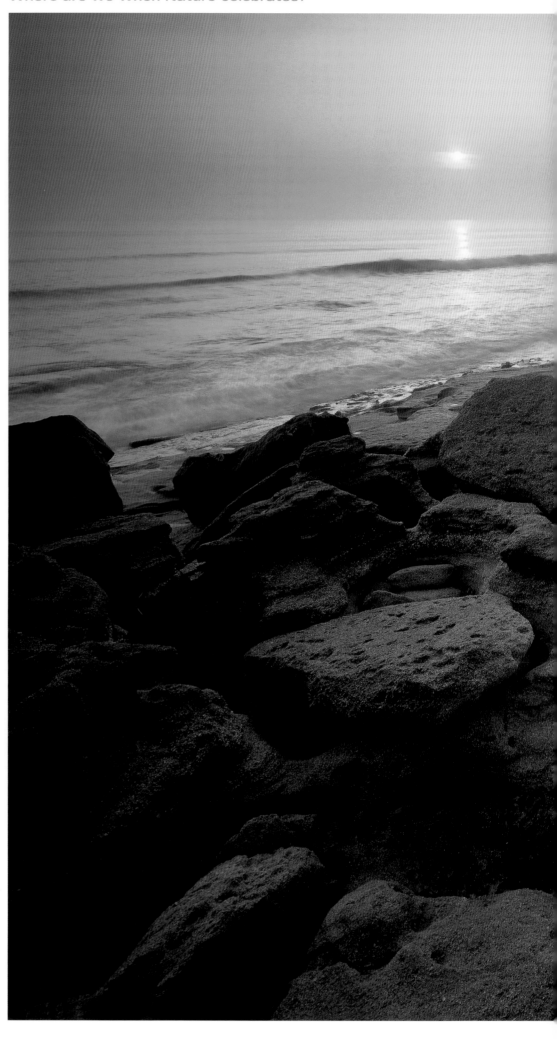

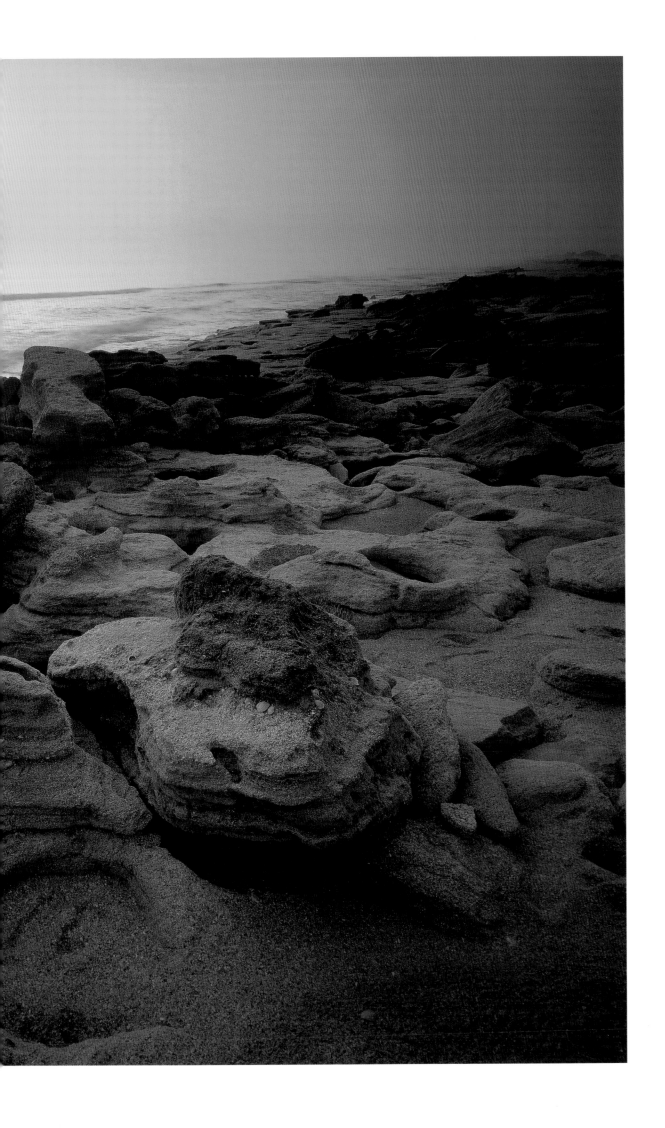

Ancient water and ancient fire . . . join as one.

The Blowing Rocks Preserve, owned by The Nature Conservancy, is a 73-acre barrier island preserve consisting of beaches, estuaries, dunes, and hammocks. During high tides and after winter storms, seas break against rocks of Anastasia Formation Limestone, blowing plumes of salt water as high as 50 feet. *The Nature Conservancy's Blowing Rocks Preserve, Tequesta.*

Rock and moonlight weave their ancient rhythm.

(Right) A waxing three-quarter moon rises over Florida's Atlantic coast as the sun sets. Ocean waves have washed away the sand, exposing coquina limestone and creating a picturesque coastal rock barren habitat. *Washington Oaks State Gardens, Palm Coast south of St. Augustine.*

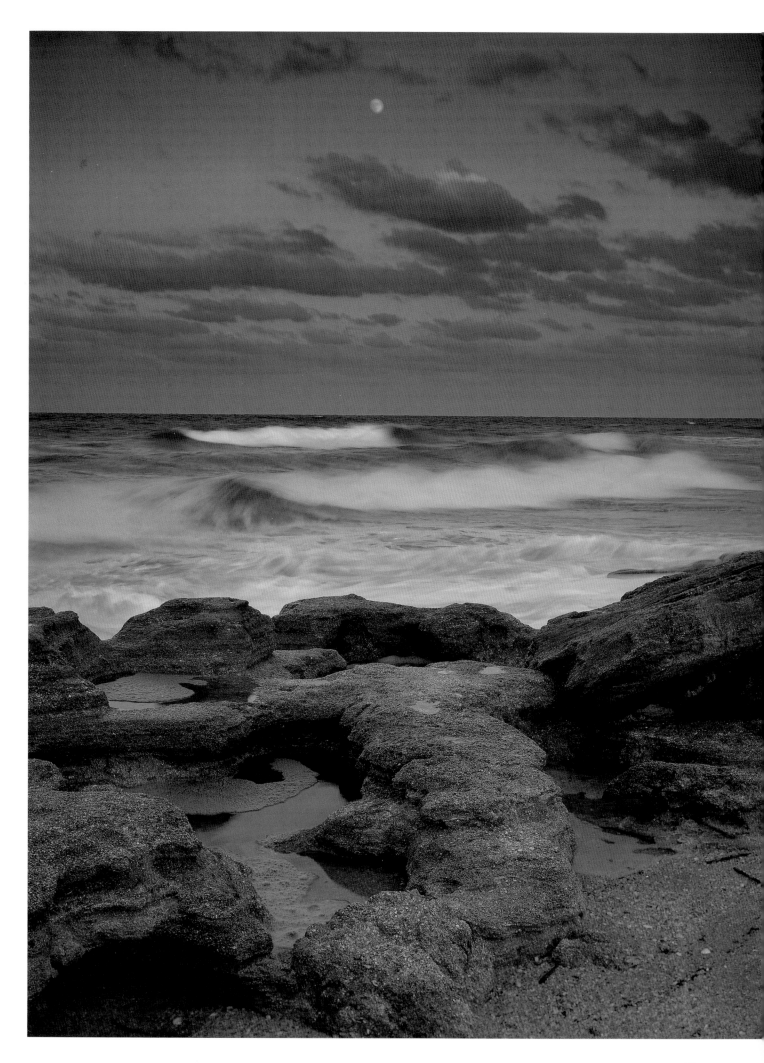

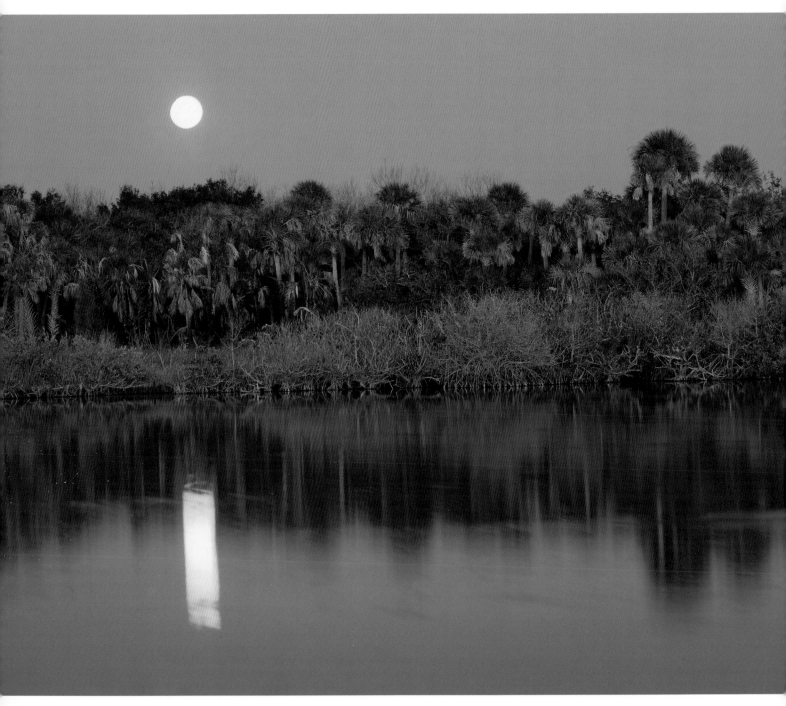

**Moon portals open the pathway to our inner truth.**

A soft full moon lends tranquility to a sable palm hammock overlooking a red mangrove estuary at Merritt Island NationalWildlife Refuge. Merritt Island is close to the 28° north latitudinal limit of mangrove distribution in the United States because mangroves cannot tolerate the colder weather much farther north. Mangroves give way to the more cold-tolerant grasses and grasslike plants of salt marshes up both coasts. *Merritt Island National Wildlife Refuge, Titusville.*

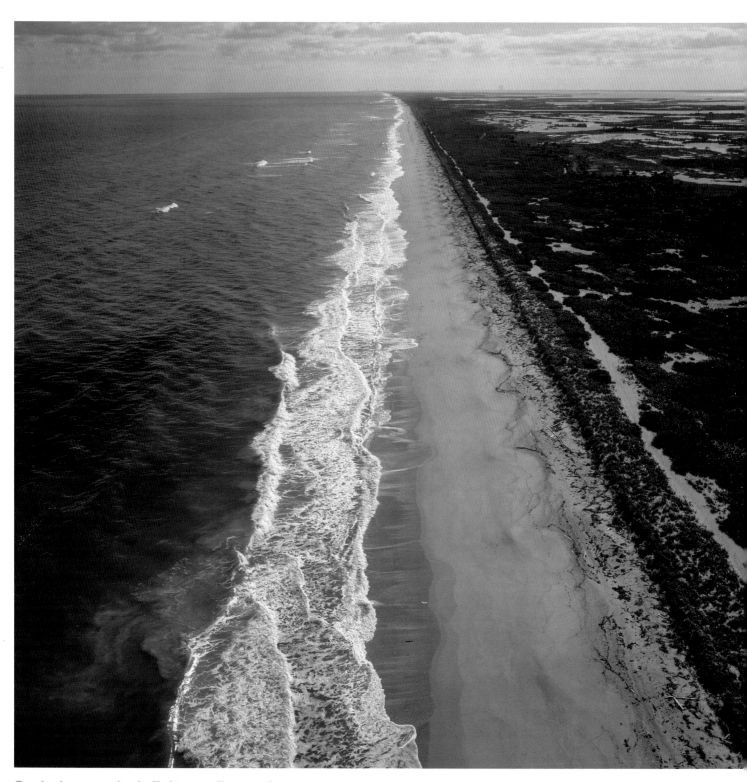

Sculpting sands, infinity reality sculpt our senses.

A classic barrier island with the intertidal zone exposed at low tide, foredune field to the right of it, then backdunes and estuarine marshes beyond. The dunes are about 30 feet, or more, high. Since we know that sea levels have more or less stabilized at present levels since about 6,000 years ago, we also know that Florida's barrier islands are only 6,000 years old or younger. Direct hurricane impacts can overwash barrier islands and their sands can be redeposited inland. *The Canaveral National Seashore/Merritt Island National Wildlife Refuge, Titusville.*

Forested dunes quietly protect our coast.

Cucumber-leaved sunflower *(Helianthus debilis)*, cabbage palm *(Sabal palmetto)*, and seagrape *(Coccoloba uvifera)* grow on a low dune beyond the beach. Upward growth of the cabbage palms has been stunted by salt spray. *John D. MacArthur Beach State Park, North Palm Beach.*

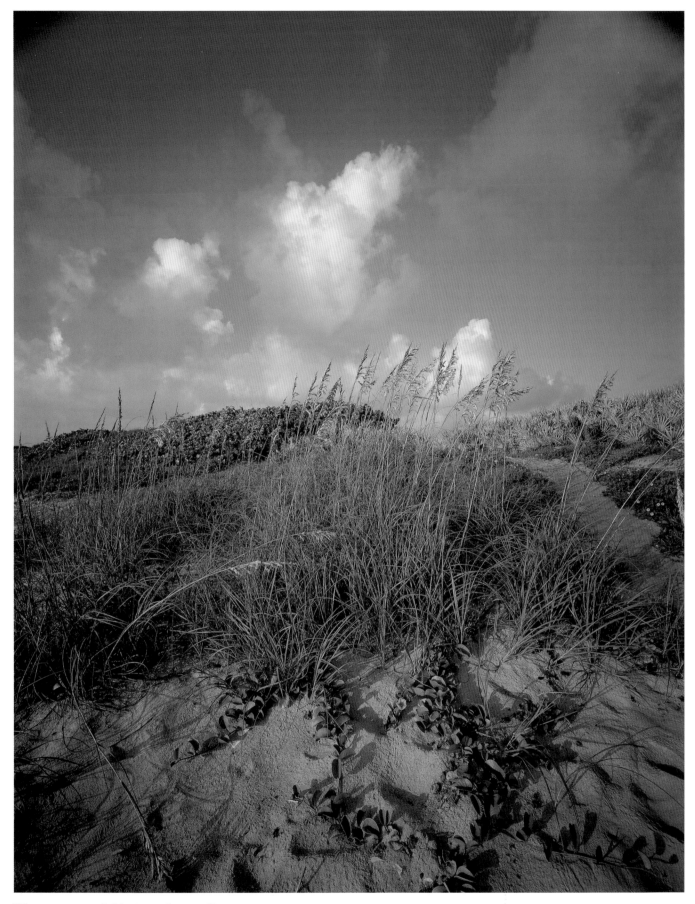

The grace of Nature is endless.

Different plants stabilize a dune. Railroad vine *(Ipomea pes-caprae)* in the foreground in flower; sea oats *(Uniola repens)* beyond; cucumber-leaved sunflower *(Helianthus debilis)* in the upper right; seagrape *(Coccoloba uvifera)* on dune crests in left background; and saw palmetto *(Serenoa repens)* in the upper right. *Archie Carr National Wildlife Refuge, Melbourne.*

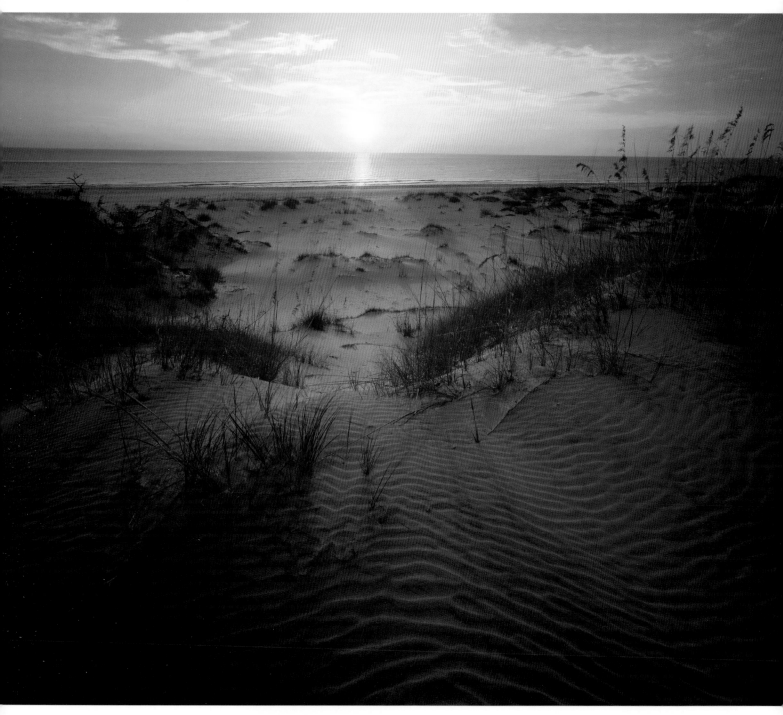

**Sunrise awakens the spirit to a newborn day.**

Sea oats seen here constantly grow upward to keep ahead of the upward growing dunes. Because of that valuable ecological service, sea oats are protected. Barrier islands first form when storms throw offshore sediments into a barrier beach that parallels the previous shoreline. Offshore winds then blow sand grains inland off the new beach during low tides. Sand may fill in the swale between the new barrier beach and the old beach and then begin to build new dunes. The sand grains are dropped when the wind is partially blocked by plants that tolerate the salt spray and hot environment. *St. Joseph Peninsula State Park, Gulf County.*

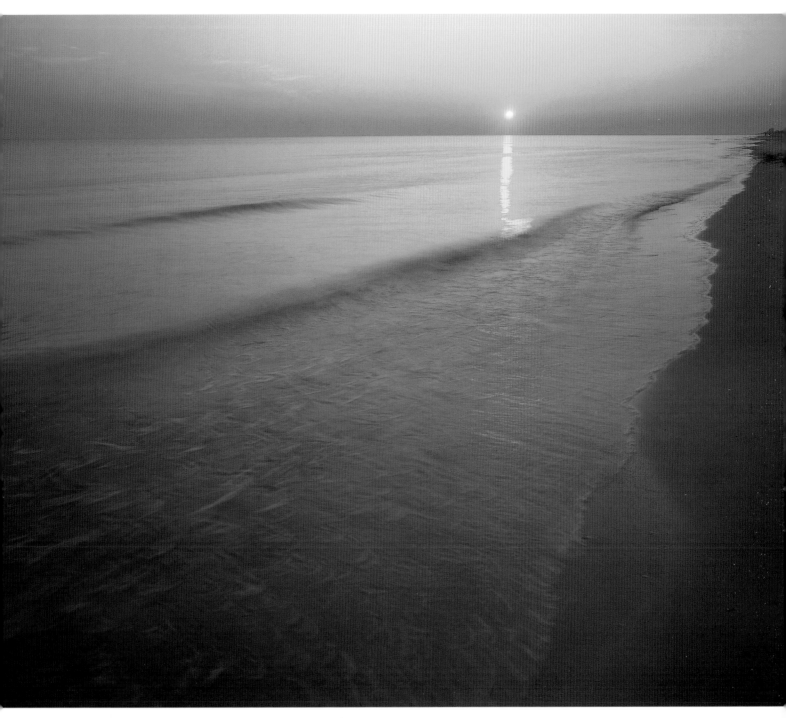

**Motionless beauty heals the soul.**

The tranquil sea and a calm beach are in contrast to hurricanes and winter storms when the beach is eroded, or, depending upon the direction of the wind, is built up by the addition of a new beach ridge. The tide rises and falls, carrying sand offshore as it rises, but adding it back when the tide is down and the wind blows inshore off the drying beach. *Grayton Beach State Recreation Area, Santa Rosa Beach.*

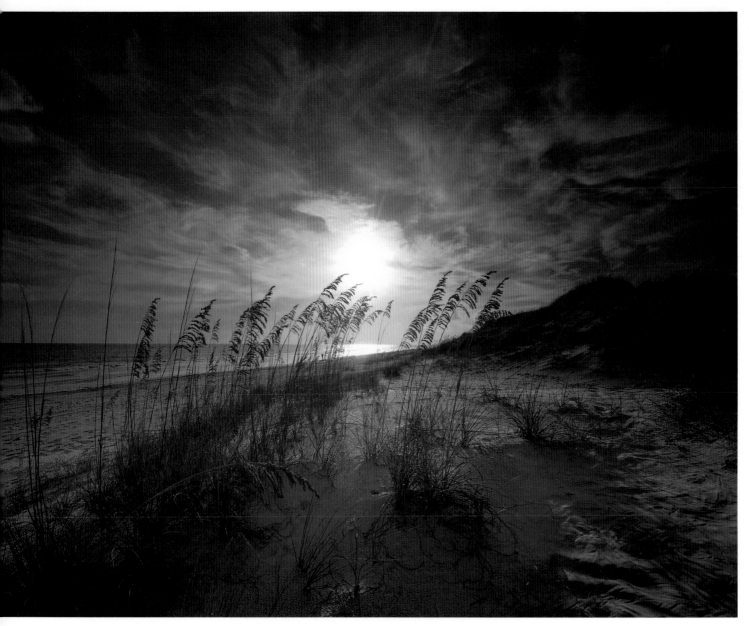

**Golden light balances the beauty radiating in your heart,
as it dances across the sands of time.**

Deer Lake State Park, Walton County, protects some of the beautiful sugar-white beaches of the Emerald Coast. A quarter-mile-long dune boardwalk prevents erosion from foot traffic while offering views of the dynamic dune ecosystems of the Gulf coast. The dunes can be blown out if stabilizing plants like sea oats are trampled, or washed into the bay during hurricanes. If left to natural processes, the dunes are restored in a few years. *Deer Lake State Park, Walton County.*

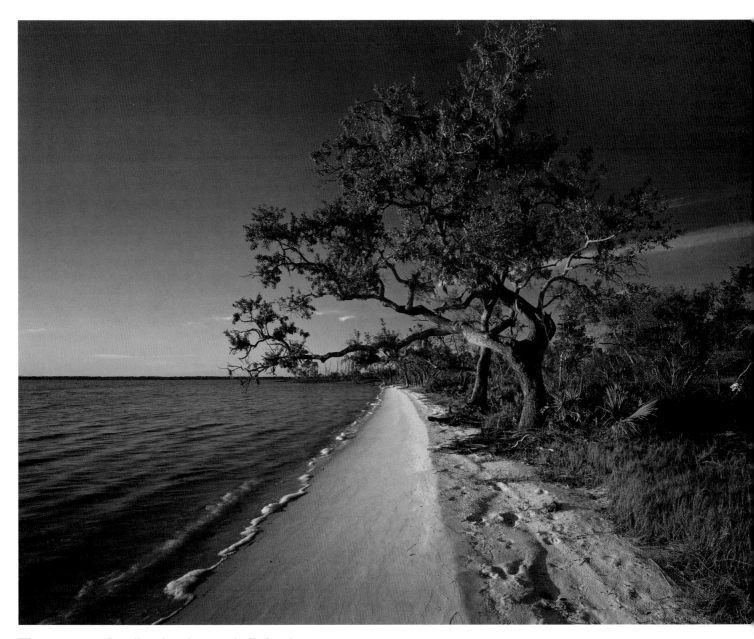

The grace of solitude shares infinite beauty.

Wind and wave action are much reduced in the protected waters of Choctawhatchee Bay. No dunes appear above the high tide line here, and the presence of liveoaks rooted in the high tide zone is evidence that sea level has been rising in the past century. All along Florida's low-energy coastlines, trees are dying from saltwater intrusion into the soils. Although this estuary is brackish, these trees cannot tolerate having their roots submerged, which is continuing to happen. *Grassy Point, Walton County.*

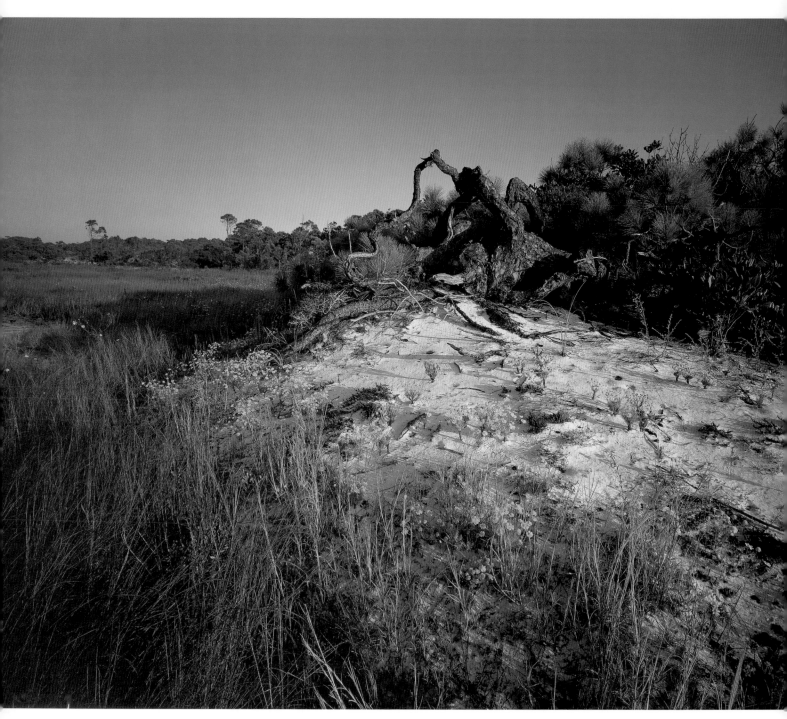

The infinite power of Nature is endless.

An ancient slash pine has tipped over and the sand clinging to its roots is being blown out by offshore winds while yellow buttons *(Balduina angustifolia)* flower all over the exposed sand in the foreground. The land transitions to a cordgrass brackish marsh. *Topsail Hill State Park, Destin.*

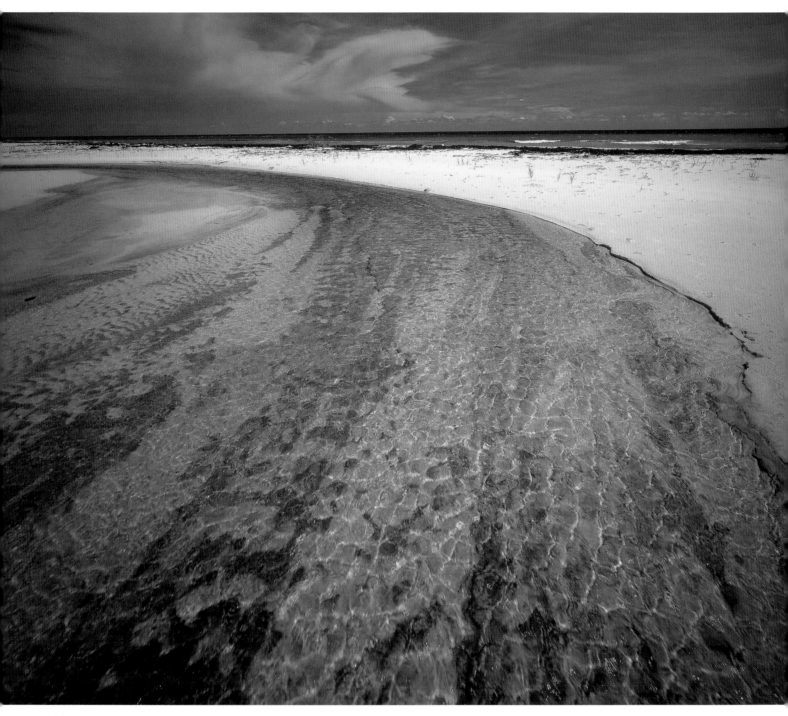

**Your path to the edge of the sea brings forth new life.**

Where freshwater meets salt—a blackwater stream exits the adjacent swampy flatwoods onto a wide, flat beach. This park offers a wide variety of ecosystems, including more than three miles of secluded white sand beaches with majestic dunes over 25 feet tall. *Topsail Hill State Park, Destin.*

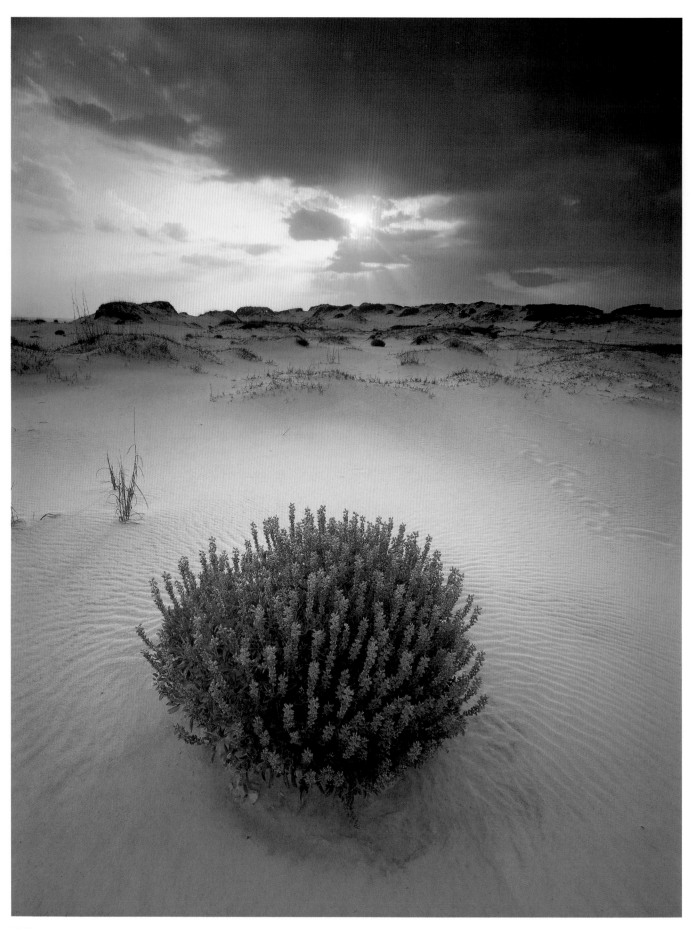

**Wisdom is measured by the precious gifts of creation.**

Gulf Coast lupine *(Lupinus westianus)* grows on an interdune flat behind the foredune field in the distance. Interdune flats often are devoid of vegetation because of high salinity from the evaporation of salt spray and seawater that accumulates in the low-elevation flat. Dune summits in the background are stabilized by sand liveoak *(Quercus geminata)*. *Camp Creek, Bay County.*

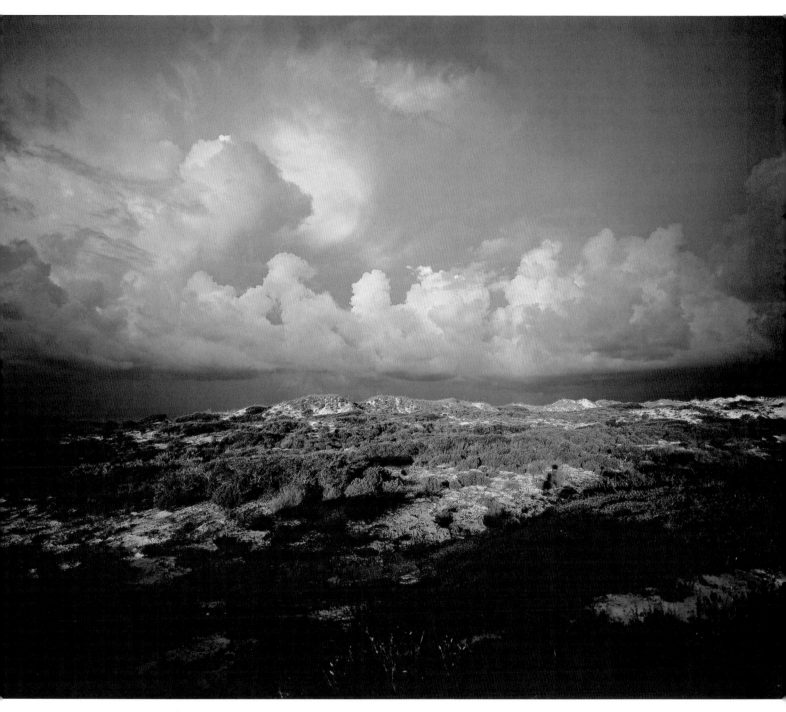

Light embraces the union of sky and sand.

Salt-pruned shrubs of sand liveoak *(Quercus geminata)* lie like hedges cropped closely to the ground with clumps and stringers of Florida rosemary *(Ceratiola repens)* in a back dune field. A passing summer storm creates dramatic skies. *St. Andrews State Park, Panama City Beach.*

Colossal sands move in concert with time.

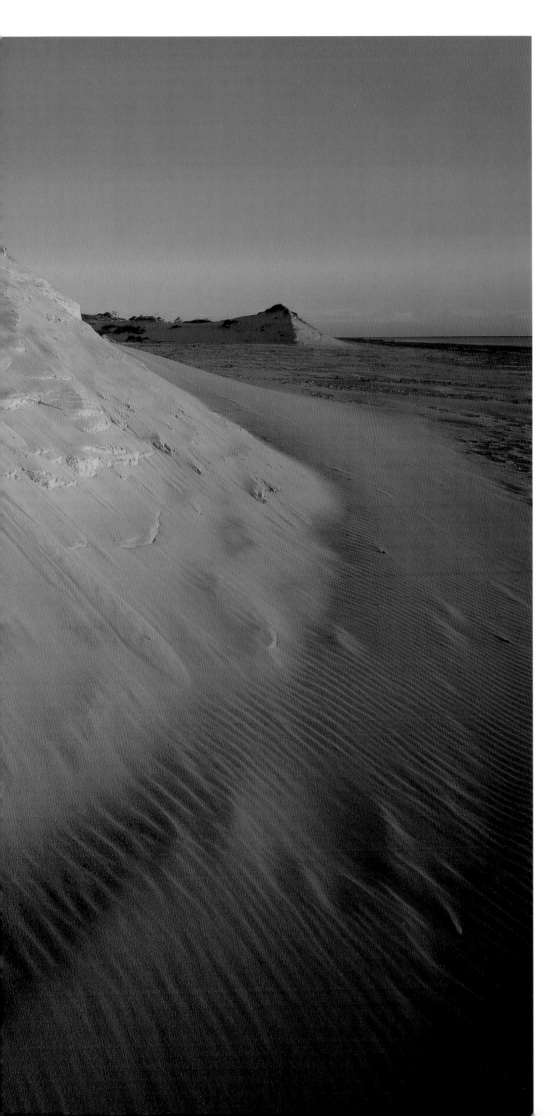

Tall dunes up to 30 feet high form in strong winds along the seaward side of St. Joseph Spit. Hurricane Opal cut this giant dune in half and washed nearby dunes across the barrier island into the lagoon behind it. A large storm-washed nick in the dunes lies just beyond the dune in the foreground. In a short time, a new dune will form in the gap. *St. Joseph Peninsula State Park, Port St. Joe.*

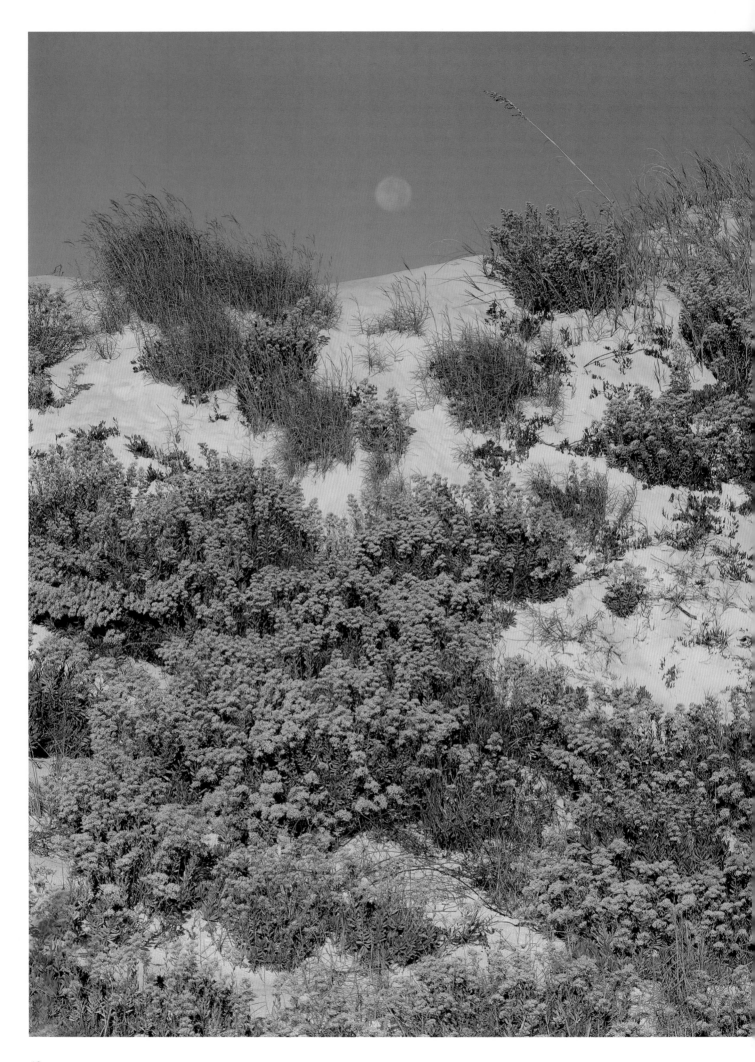

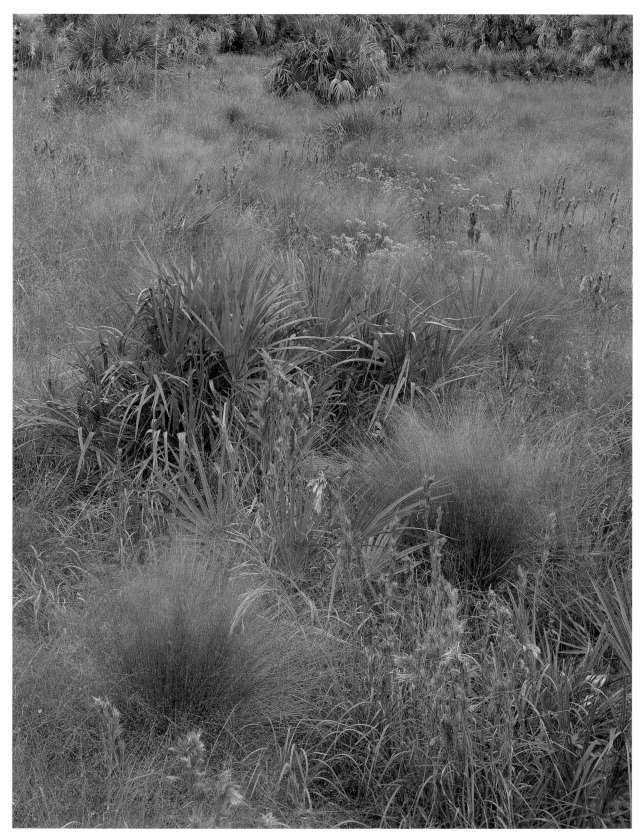

The exquisite matrix of life decorates our senses.

Red-top grass *(Muhlenburgia capillaris)*, bluestem *(Andropogon scoparius)*, and a dogfennel *(Eupatorium* sp.) flower among saw palmetto *(Serenoa repens)* clumps. *Caladesi Island State Park, Dunedin.*

Dunes celebrate their flowers holding the golden light.

(Left) Seaside goldenrod *(Solidago sempervirens)* and sea oats *(Uniola paniculata)* are stabilizing this large dune. Without such plants, the sand would blow inland until something else intercepted it. Otherwise, it would blow across the barrier spit into the lagoon beyond. Regardless of stabilizing plants, when hurricane winds blow inland, even large dunes can be blown into the lagoon. *St. Joseph Peninsula State Park, Port St. Joe.*

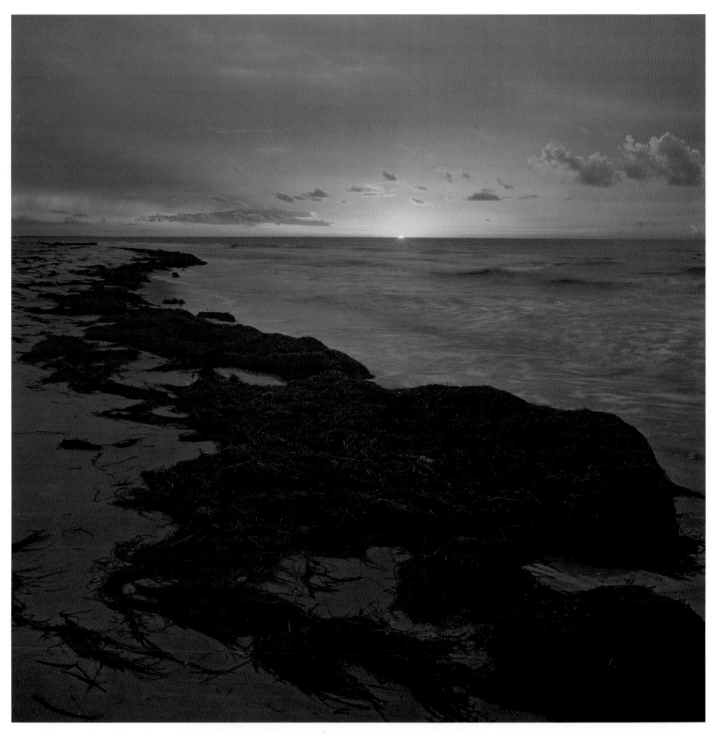

Awaken / Awakening / Astonishing

First dawn paints a glow over another day on the beaches of St. George Island. Tidal wrack on the beach feeds myriad small invertebrates that in turn feed dozens of shorebirds. When the moldering vegetation is decomposed, the nutrients will return to fertilize the sea. *St. George Island State Park, Eastpoint.*

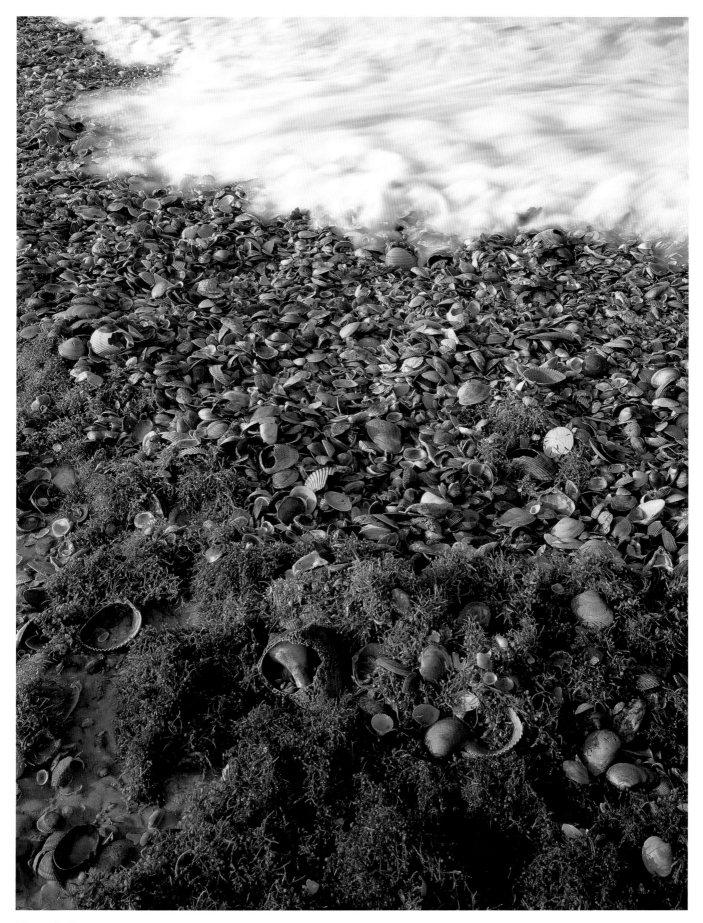

The divine magical carpeting of Nature intoxicates the soul.

Tossed up on the beach by a heavy surf, clams, scallops, sand dollars, coquinas, and seaweed carpet the remote shores of some beach wilderness areas in the Florida panhandle. Such a profusion of life reflects a healthy and thriving offshore estuarine habitat. *Little St. George Island, Franklin County.*

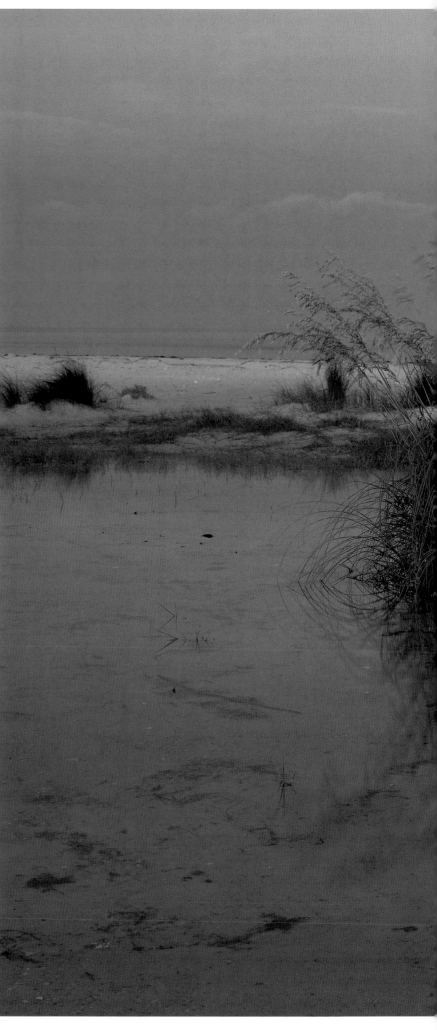

Interdune flats get inundated with fresh water after a rain, but the water soon percolates downward, coming to rest as a freshwater lens on briny waters underneath. So long as it rains, the freshwater lens will be rejuvenated, but in droughts, the fresh water would eventually mix with the brine. Shallow wells tap into the freshwater lens on barrier islands, but as every resident will tell you, during droughts, the tap runs salty and smelly. *St. George Island State Park, Franklin County.*

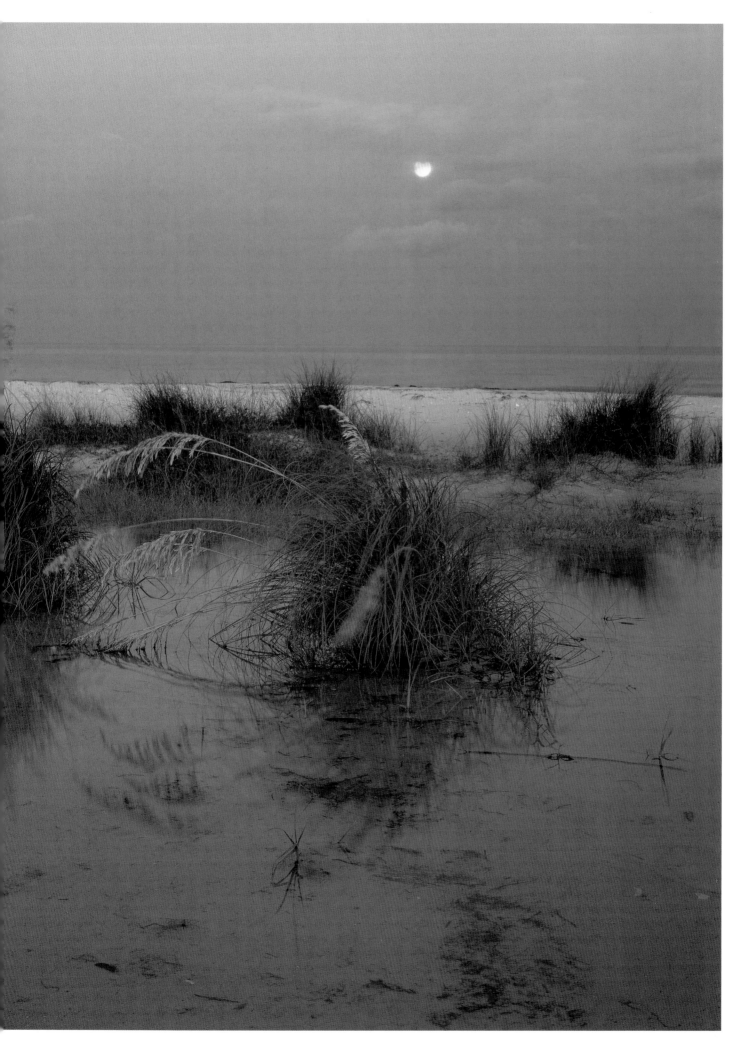

Extensive salt marshes fringe the coastline around Florida's Big Bend because the adjacent continental shelf is shallow, resulting in what is called a low-energy coastline. Energy relates to the power of wave action, here muted because great waves cannot be developed over shallows. Instead, a good wind only whips up a little sea foam. *Big Bend Coast.*

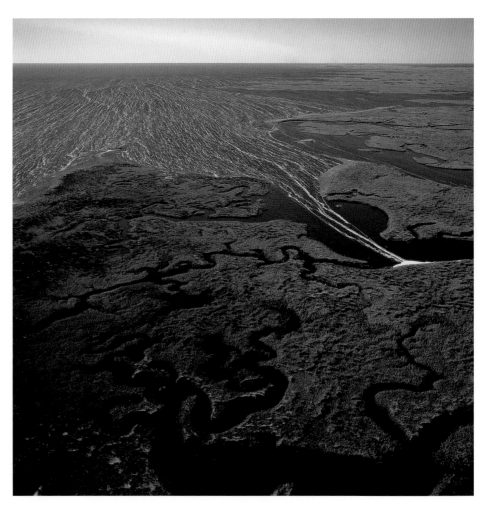

Enchanted water—matrix of beauty.

Looking inland from the mouth of the Big Bend's Econfina Creek, salt marshes grade into coastal forests, first met by ranks of cabbage palms, then hydric hammock with ten to fifteen species of hardwood trees and cypress. Further inland, a forest of mixed loblolly pines and hardwoods is met and eventually grades into longleaf pine flatwoods. *Econfina State Park, Big Bend Coast.*

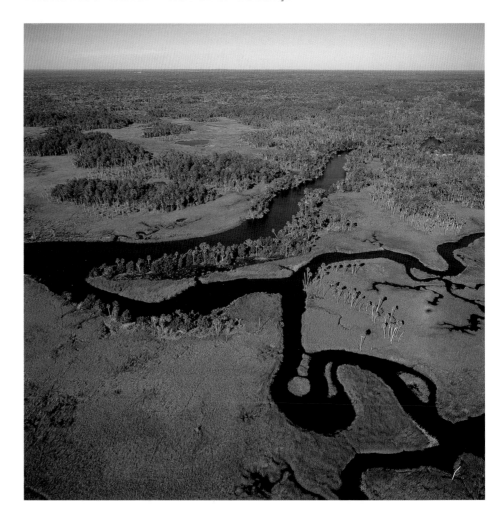

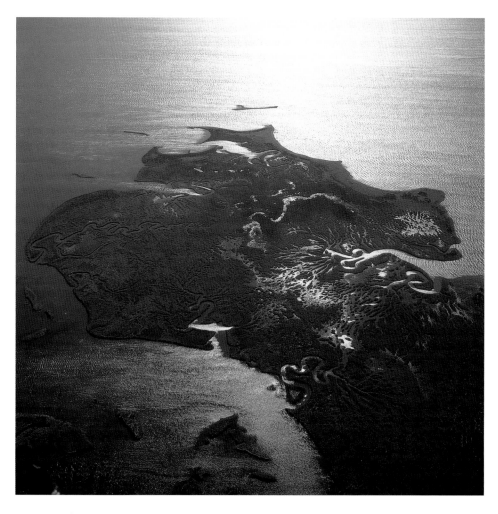

Tidal creeks snake through coastal salt marshes, distributing brackish water in and out of the sea. The water here is not strictly salt water because of numerous creeks bleeding fresh water out of the adjacent land. Offshore beyond the salt marshes lie Florida's largest seagrass beds, one of its most productive habitats for marine life. *Big Bend Coast.*

**The mystery of light and land.**

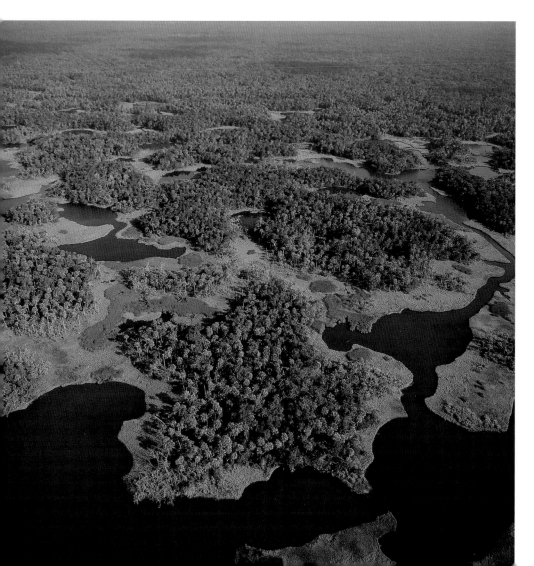

Freshwater marshes grade into salt marshes near the coastline of Florida's Big Bend. There, cabbage palm is the first tree species met going inland, occurring in single-species stands because it is the tree most tolerant of salt water. Soon it becomes mixed with hardwoods to form a type of coastal hammock. Leaf litter from the hammocks washes into the estuary and enriches it with valuable nutrients and particulate organic matter important to aquatic wildlife. *Gulf Hammock State Preserve, Big Bend Coast.*

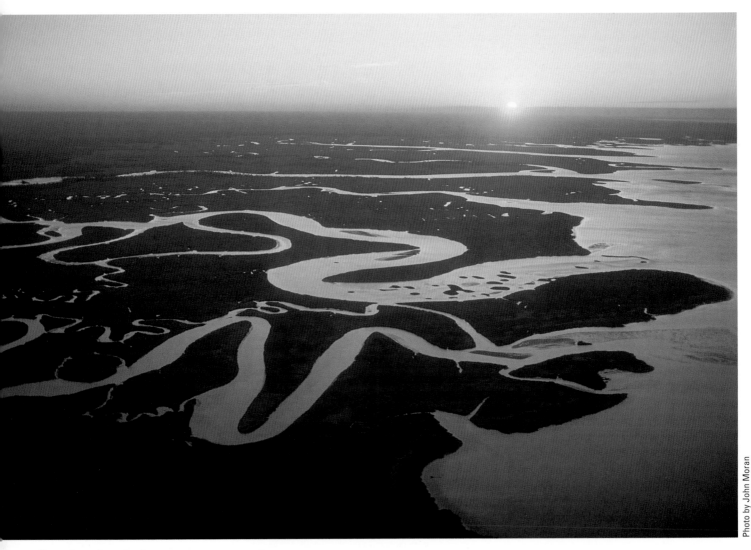

**A miracle happens every day.**

Beginning as a modest stream flowing out of the Okefenokee Swamp, the Suwannee River completes its 240-mile journey to the Gulf in grand fashion, daily pouring forth some eleven billion gallons of water into the estuary. Streams visible in this aerial sunrise view include, from foreground back: Hog Island Creek, Moccasin Creek, Raulerson Creek, the East Pass of the Suwannee, Dan May Creek, and Barnett Creek. *Levy and Dixie Counties.*

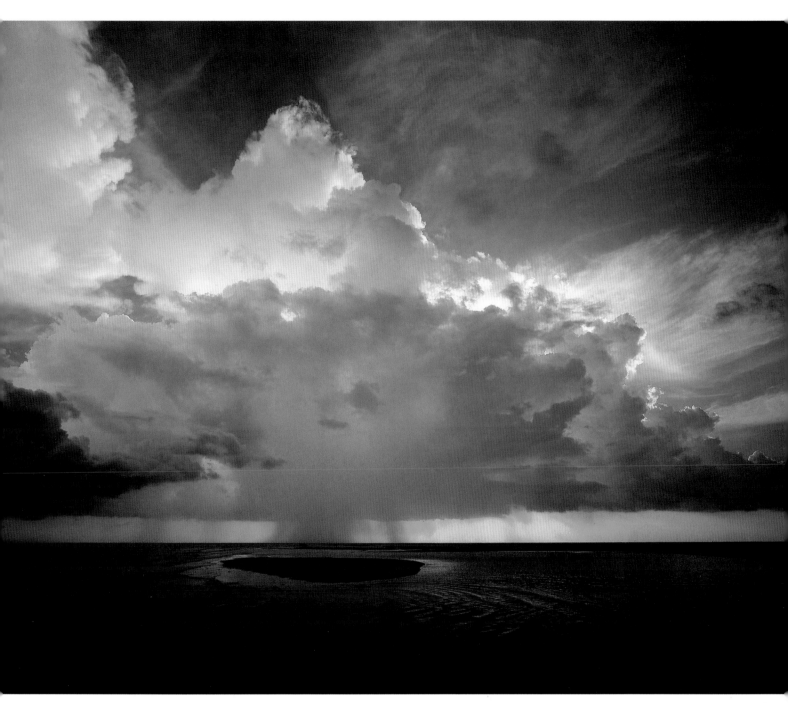

Islands in time: dissolve, evolve.

The oceans of the world are the source of all earth's water. Fresh water evaporates from the oceans, moves inland in the form of atmospheric moisture, rains down upon the soil, and returns to the sea via rivers and underground circulating groundwater. Some re-evaporates into the air, and, as here, returns directly to the sea without passing overland.
*Cayo Costa State Park, Boca Grande.*

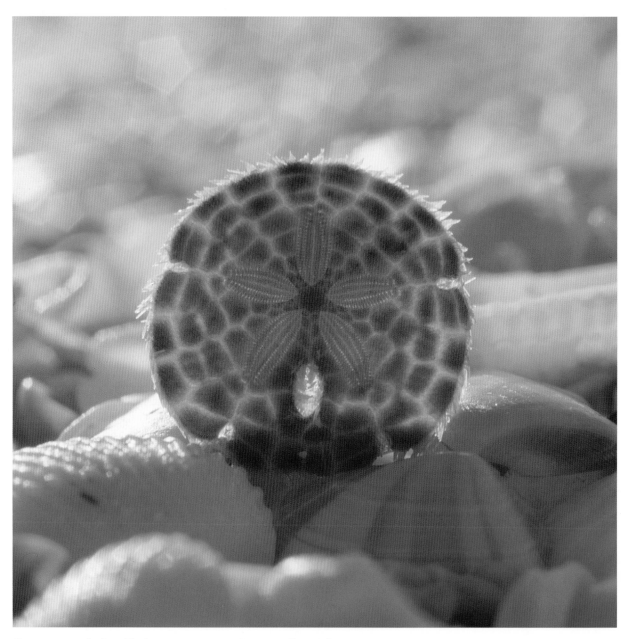

**Secrets of the Universe come in small packages.**

Sun penetrates a sand dollar the size of a baby's fingernail resting on a coquina shell. Echinoderms and mollusks, ground to tiny bits by wave action, make up the sands of many of Florida's eastern and southwest coast beaches. *Sanibel Island.*

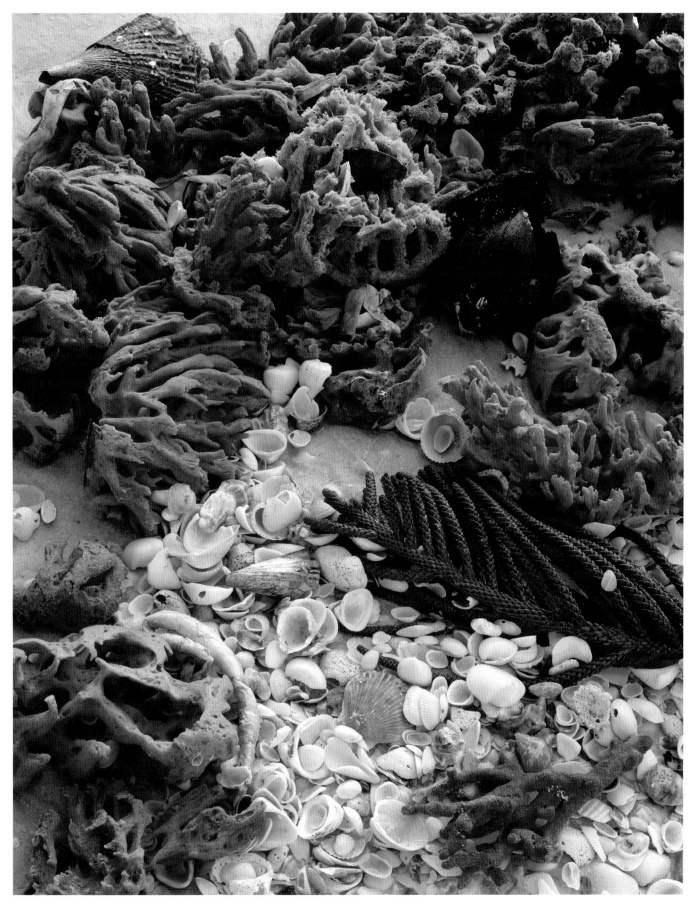

Nature's adornment in perfect performance.

Florida's southwest coast is famous for its sponges and mollusks. A sponge industry thrived for decades in the mid-20th century out of Tarpon Springs until synthetic sponges replaced them. Shelling beaches draw thousands of visitors each year, but the removal of seashells can have detrimental environmental consequences if too many are removed. For one thing, the sand of many beaches is composed of shell fragments. Hurricanes and high tides leave sponges and shells adorning the beach. *Little Marco Pass Beach, Rookery Bay Aquatic Preserve, south of Naples.*

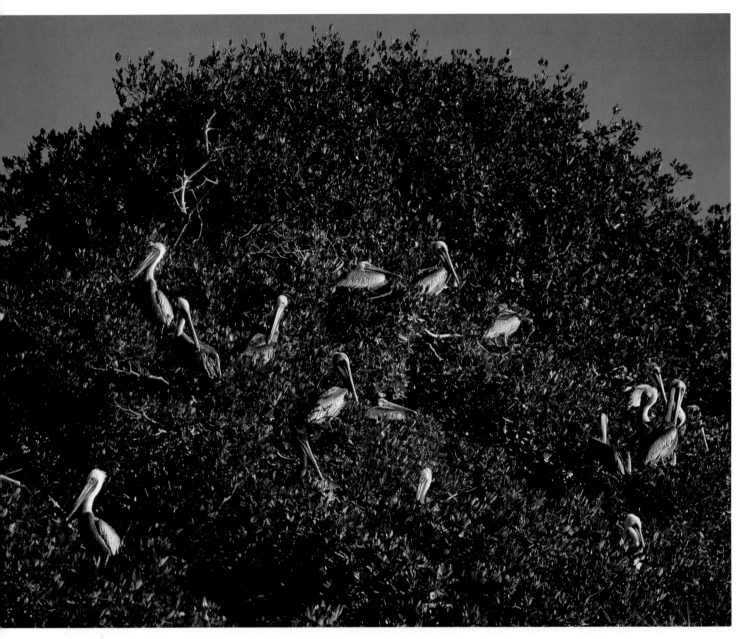

**Tree of life, decorated with beautiful flying creatures.**

Brown Pelicans take shelter on their mangrove rookery. Mangroves, rooted in seawater and often occurring as islands off south Florida, provide safety from mainland predators such as raccoons, opossums, bobcats, foxes, and even black bears. *Rookery Island, Rookery Bay Aquatic Preserve, Rookery Bay National Estuarine Research Reserve, south of Naples.*

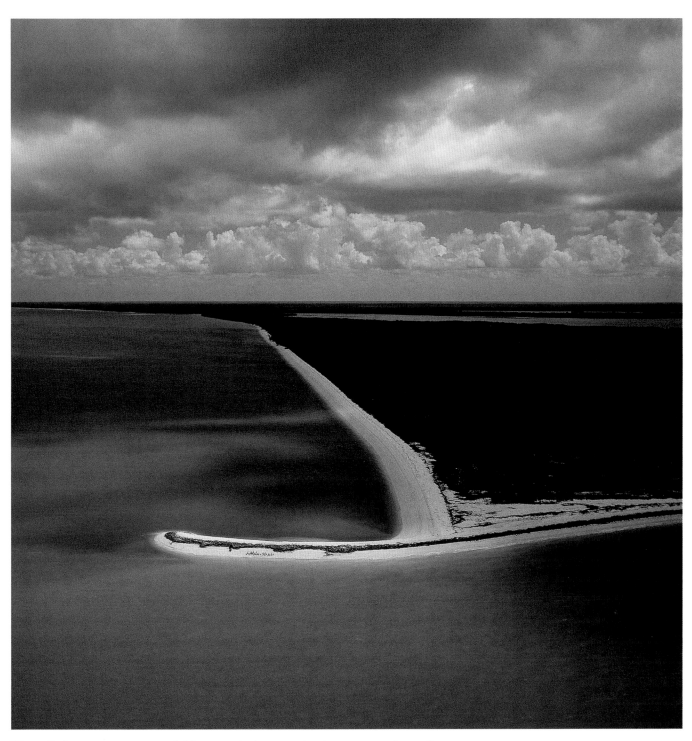

**The divine presence of Nature brings what we need on time.**

A tiny sandspit forms as currents move sand right to left in this image, then waves pile the sand up into a continually elongating beach ridge. The spit and the coastal beaches form valuable habitat for shorebirds and marine wildlife that the shorebirds seek to eat. Beaches are not solely for sunbathing. They are a vibrant living ecosystem of their own. The green color of the water is due to excessive algae growth. *Middle Cape, Everglades National Park.*

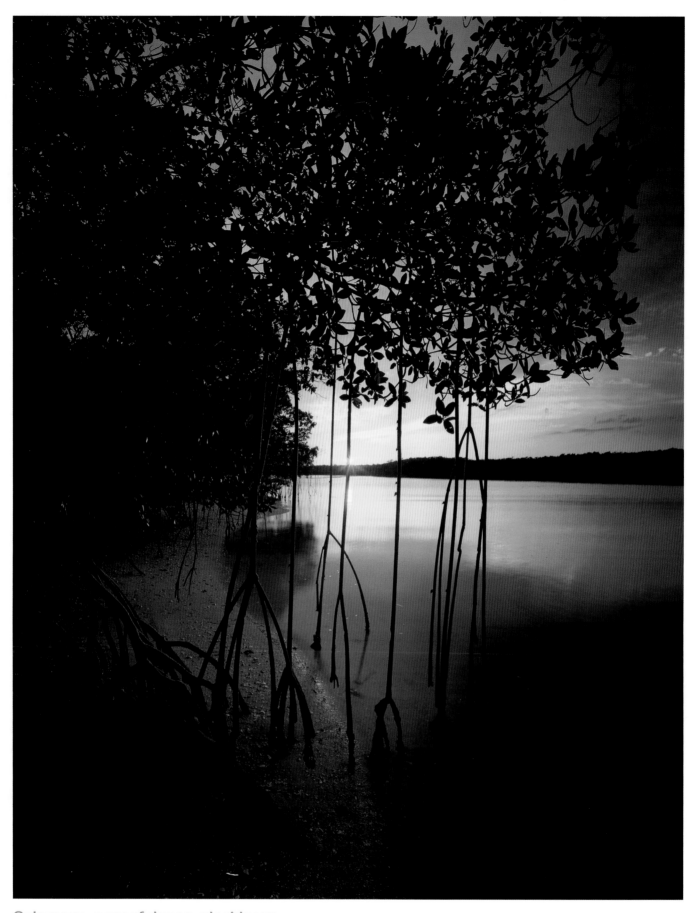

**Calmness, peacefulness, placidness**

Aerial prop roots of red mangrove *(Rhizophora mangle)* drop into the muds of tidal swamps along Florida's southern coast. They are elongated legs and feet marching waterward and will be stopped only when the water is too deep. Mangroves form another of the world's valuable nurseries for fishes and other marine life by providing structure for hiding and attaching to, plus particulate organic matter for food and nutrients. *Cape Romano, Ten Thousand Islands Aquatic Preserve, south of Marco.*

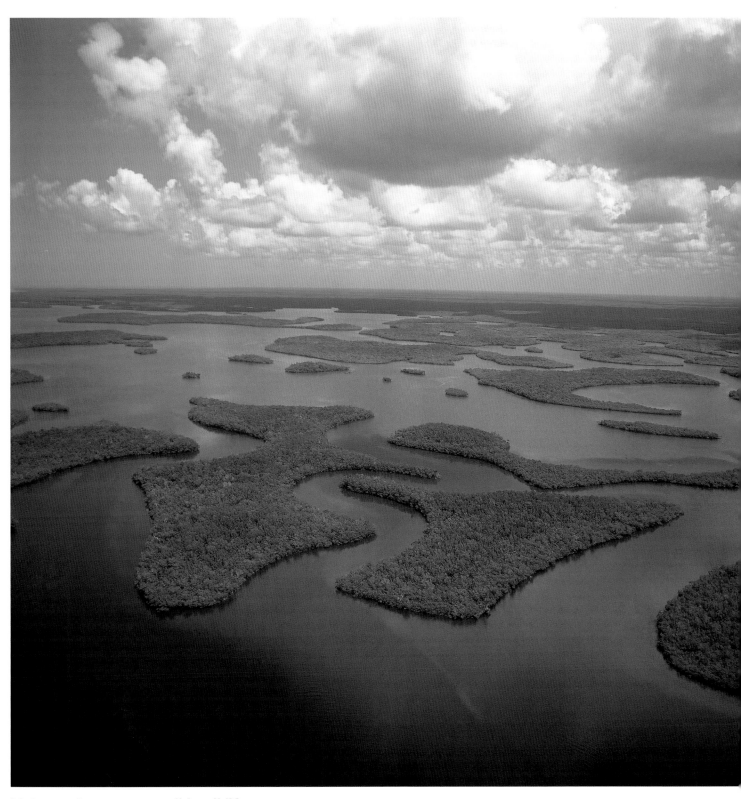

Light anoints every cell in all life.

Myriad mangrove islands, channels, bays, oyster bars, and creeks cover nearly 200,000 acres of coastline at the southwestern tip of Florida. As part of this larger system, this 35,000-acre refuge provides a regional coastal buffer. Approximately 200 species of fish inhabit the seagrass beds and mangrove bottoms serving as a vital nursery area. Over 189 species of birds use the refuge, including wading birds, shorebirds, diving water birds, and raptors. *Ten Thousand Islands National Wildlife Refuge, south of Marco.*

Florida Bay is a large expanse of water bounded by the southern tip of Florida, the Gulf of Mexico, and the Florida Keys. It is underlain by shallow mud banks less than ten feet in depth, which are almost exposed at low tide. Florida Bay is less saline than seawater because the dominant water input to Florida Bay is runoff from the Everglades, seen here as tannic fresh water flowing right to left. *Everglades Bay, Everglades National Park.*

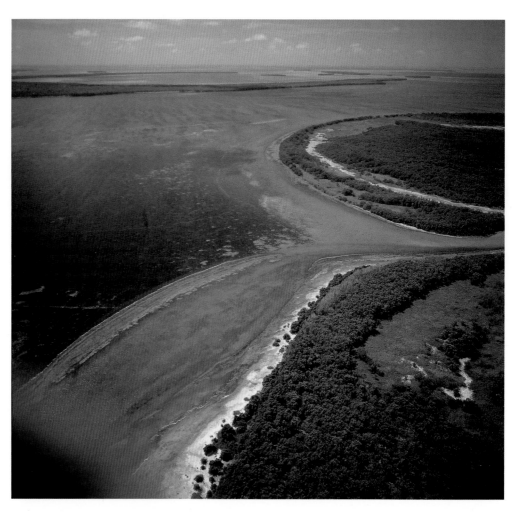

A journey in paradise awaits us.

Low, flat islands composed of carbonate mud, sand, and shelly gravel are abundant in Florida Bay and are densely covered with mangrove forests. Besides providing food and hiding places for aquatic wildlife, many of the small mangrove islands serve as rookeries for herons, egrets, and other wading birds. *Cuthbert Lake, Everglades Bay, Everglades National Park.*

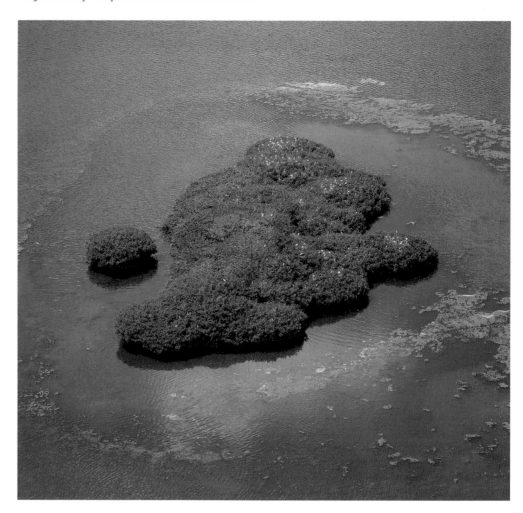

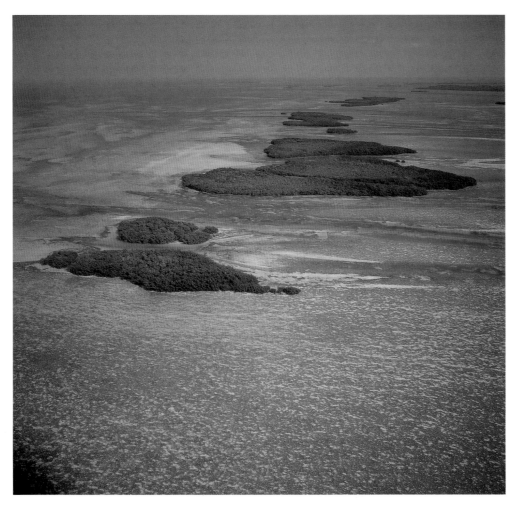

A diversity of aquatic marine environments lies along the Florida Keys. Coral reefs thrive in the clear, deep waters on the continental shelf to the east (left). Channels between mangrove islands serve as conduits for pure seawater to flow into the shallow waters of Florida Bay, dominated by seagrass *(Thalassia testudinum)* beds. *National Key Deer Refuge, Big Pine Key.*

A journey in paradise awaits us.

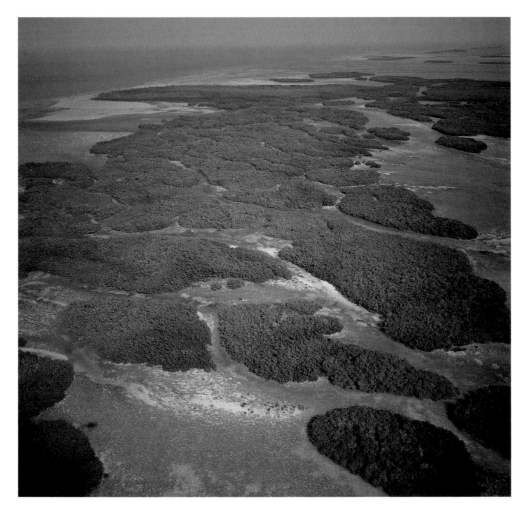

The Key West National Wildlife Refuge, lying 140 miles southwest of Miami and immediately west of Key West, is accessible only by boat. The refuge encompasses more than 200,000 acres, but with only 2,000 acres of land, mostly mangrove islands. The islands are home to more than 200 species of birds and are important for sea turtle nesting. *Key West National Wildlife Refuge, Monroe County.*

One of a group of islands in the Middle Keys, this small island lies in shallow water between Hawk Channel and Florida Bay. Surrounded by seagrass beds and patches of sandy bottom, its mixed grassy and shrubby interior is fringed by mangroves. *Curry Hammock State Park, Little Crawl Key.*

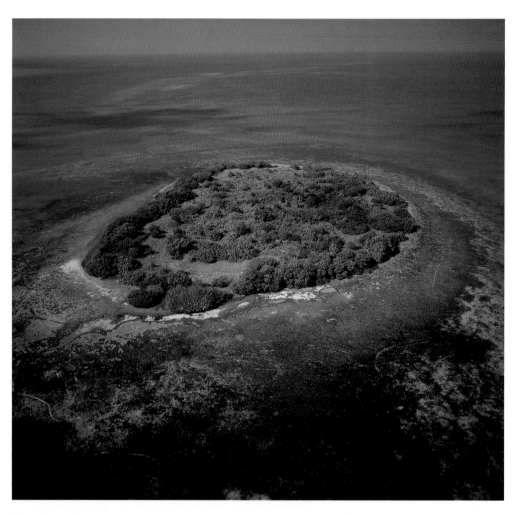

Earth, a fertile place sharing so much life.

One of Florida's four species of mangroves, black mangrove *(Avicennia germinans)* grows inland on the shore where it can be reached only by high tides. Its numerous pencil-like breathing tubes—called pneumatophores—grow vertically up from the mud to just above the highest sustained high-water level. *Indian Key Historical Site, Florida Keys*

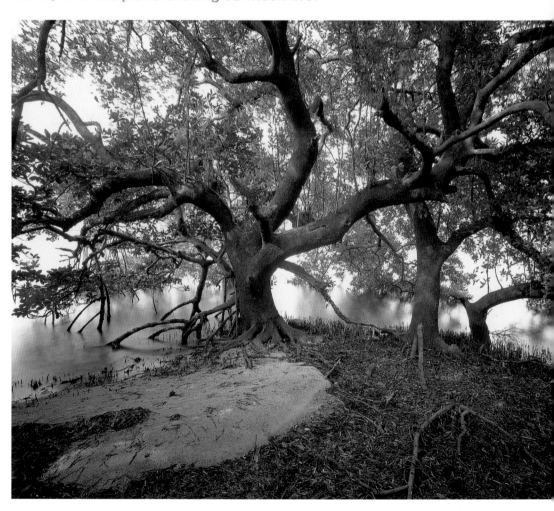

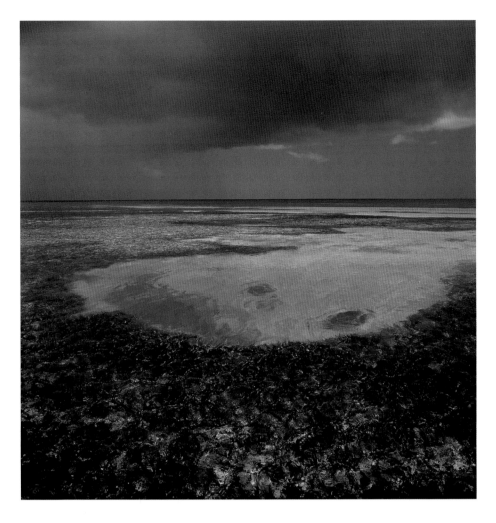

Seagrass beds are essential to Florida's marine ecology. They provide habitat in which many marine creatures live, as well as food for animals such as manatees and green sea turtles. Other animals, such as crabs, shrimps, and fish, live in it or eat the algae growing on its blades. Bare, sandy sea bottoms are home to sea life, too, hiding clams, crabs, stingrays, and other fish that bury in it. *Key West National Wildlife Refuge.*

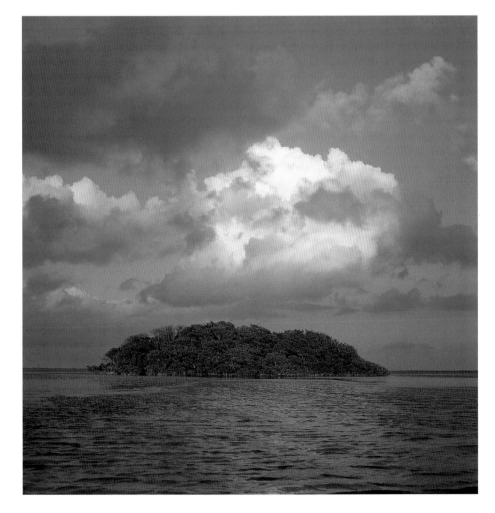

A mangrove island, part of an uninhabited atoll about 30 miles west of Key West. Only the Dry Tortugas lie farther west along the chain of Florida Keys. These islands are almost always surrounded by a naturally formed mote of shallow water. The tidal range shows on the base of the mangrove trees, low tide at the moment. *Marquesas Keys, Key West National Wildlife Refuge.*

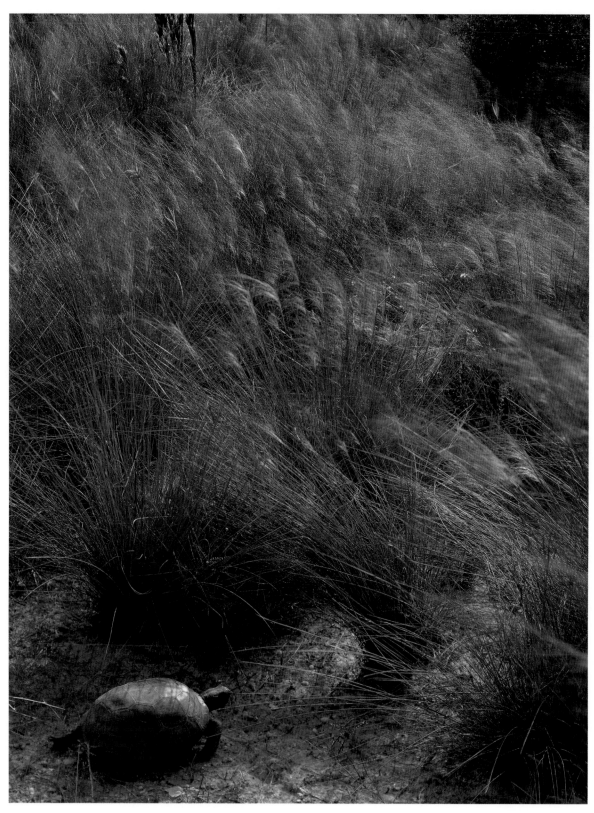

**Wild forever in a vast wilderness.**

The gopher tortoise *(Gopherus polyphemus)* is an important keystone species with more than 300 other species depending on its burrows. This dry land turtle digs burrows averaging 25 feet long and eight feet deep, in which it lives in open-canopied habitats, mostly longleaf pine forests and sand pine and coastal scrubs. *Caladesi Island State Park, Dunedin.*

**So tiny—so brave—so wise.**

(Right) The mangrove terrapin *(Malaclemys terrapin rhizophorarum)* is a south Florida race of an aquatic species of turtle that lives in salt marshes and other estuarine habitats along the coastal margins of the eastern United States. *FPL Everglades Mitigation Bank, Homestead.*

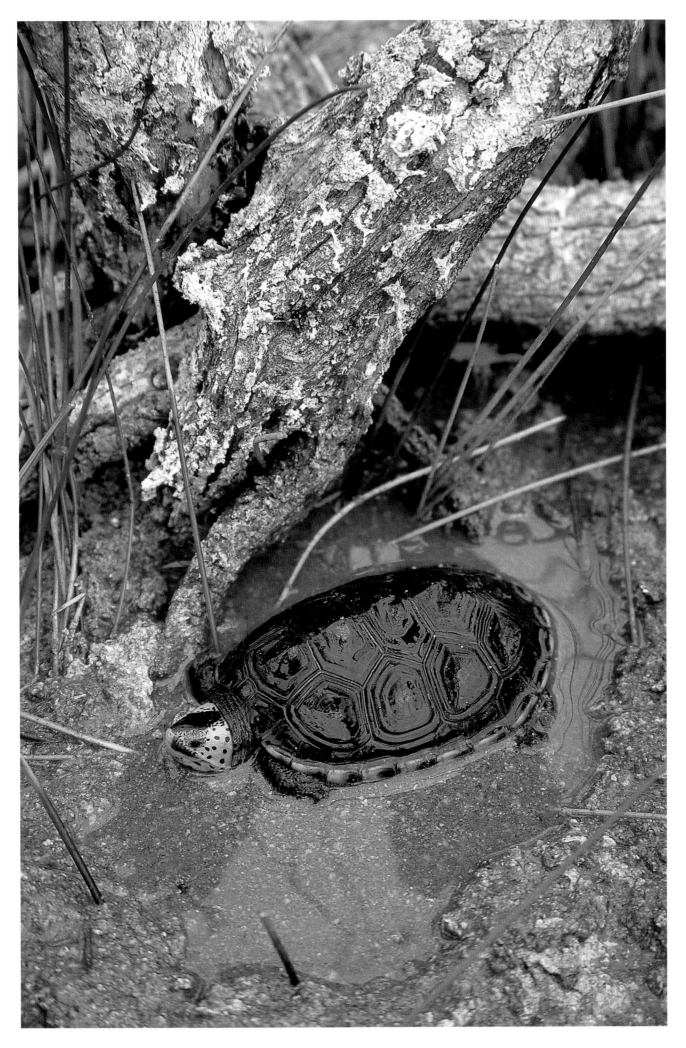

(Right) The American white pelican *(Pelecanus erythrorynchos)*, weighing up to twenty pounds, is one of the largest birds in the world able to take off in flight from the ground. *Cypress Gardens Wading Bird Exhibit, Winter Haven.*

(Below) American white *(Pelecanus erythrorhynchos)* and brown *(Pelecanus occidentalis)* pelicans take flight over their winter feeding grounds along Florida's Nature Coast. White pelicans are one of North America's largest birds, with a body over five feet long, a wingspan over nine feet, and weighing in at an average of 16 pounds. Once endangered because of the build-up of pollutants in its diet, it has made a remarkable recovery and is no longer on the endangered species list in the U.S. The brown pelican is smaller, weighing six to twelve pounds with a wingspan of six to eight feet. White pelicans take their food by dipping it while floating on the water's surface, but the brown pelican dives for its fish prey. *Gulf Coast.*

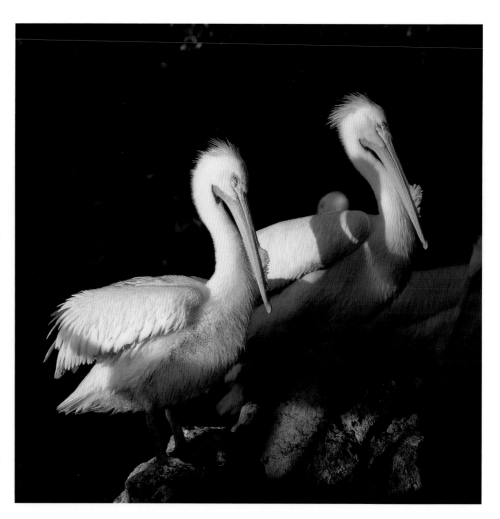

Wings of wisdom . . . wings of freedom . . . forever we fly . . .

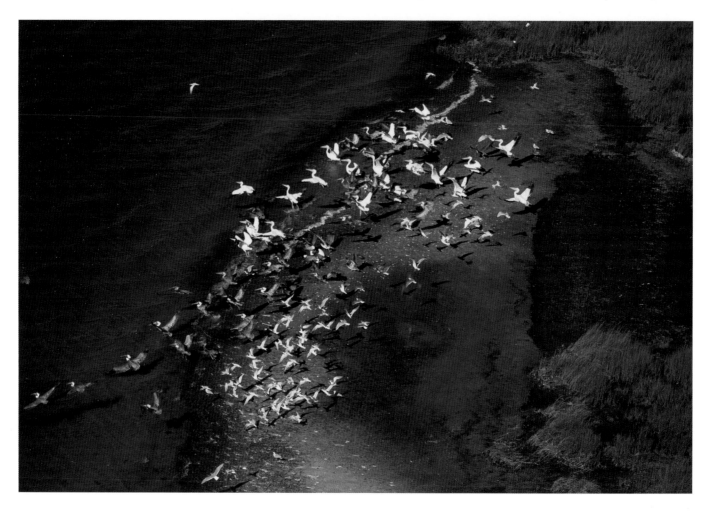

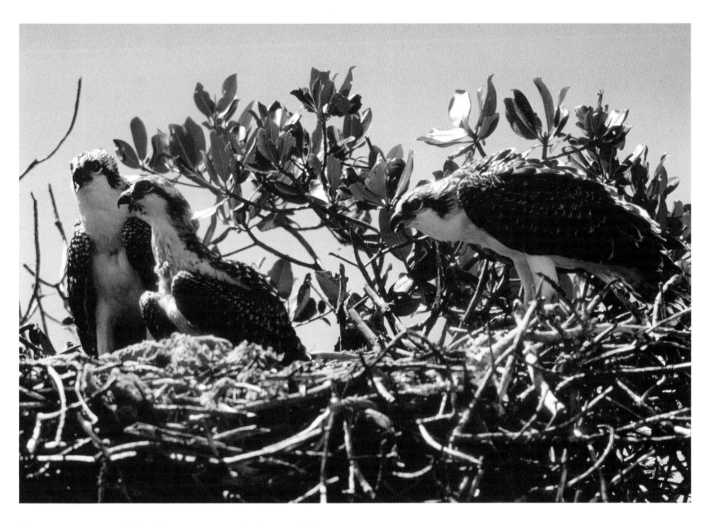

The nest—our first home to celebrate life.

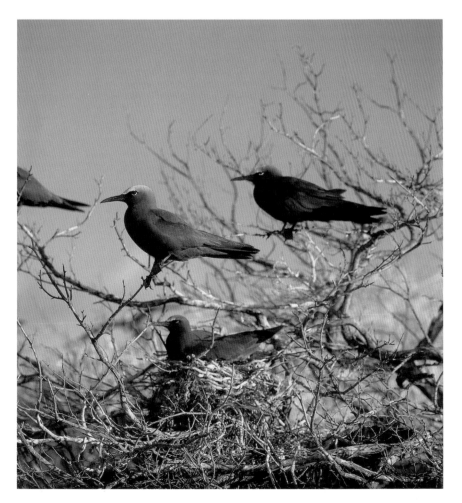

(Above) Young ospreys *(Pandion haliaetus)* sit in a classic stick nest common on telephone poles or tall trees along Florida's coastline, lakes, and rivers. The osprey, sometimes called the sea hawk or fish eagle, is a daytime active raptor whose diet is 99 percent fish that it catches by plunging feet first into the water. It is the second of the world's most wide-ranging raptors, occurring on all continents except Antarctica. Only the peregrine falcon is more widely distributed. *Key West National Wildlife Refuge, Florida Keys.*

The brown noddy *(Anous stolidus)* is a dark brown tern that spends most of its life out at sea. It is rarely seen north of south Florida, where it nests only on Bush Key in the Dry Tortugas in colonies with the sooty tern. Brown noddies eat primarily small fish by pouncing on them at the water's surface rather than diving as most terns do. They are fond of perching on floating pieces of driftwood, but occasionally float on the water. *Fort Jefferson National Monument, Bush Key.*

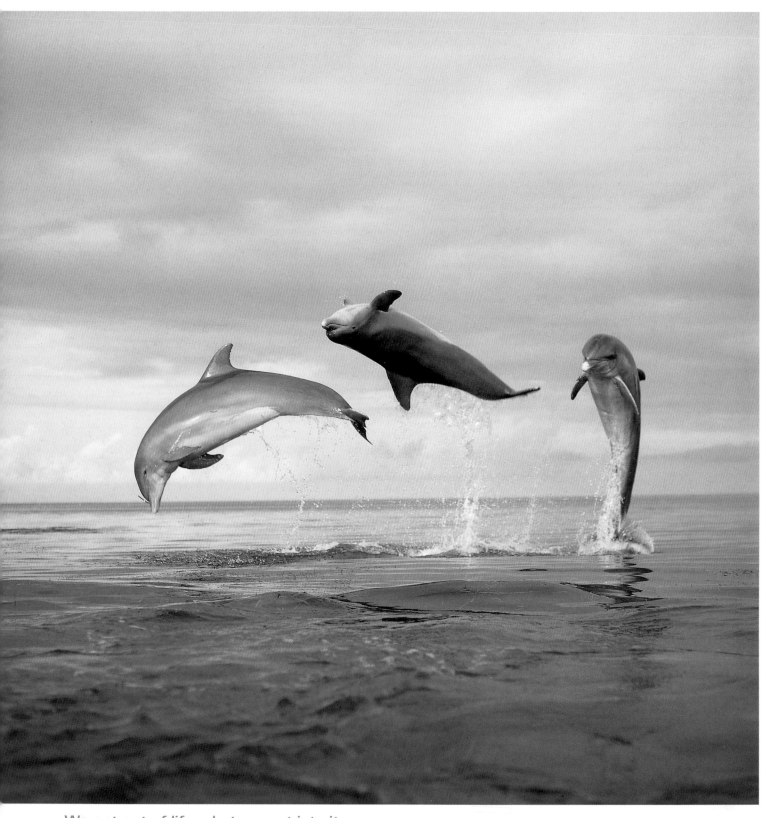

**We get out of life what we put into it.**

The bottlenose dolphin *(Tursiops truncatus)* is one of the 79 aquatic mammals called cetaceans, a group that includes whales and porpoises. Bottlenose dolphins may grow to twelve feet long and are identified by characteristic markings on the dorsal fin. A species of special concern in Florida, the bottlenose dolphin needs unpolluted waters to sustain a healthy existence. They are found all around Florida in the waters of the Gulf of Mexico and the Atlantic Ocean. *Dolphin Research Center, Grassy Key.*